LIBRARY
Montana State University
Bozeman

BRADLEY G. MORISON

JULIE GORDON DALGLEISH

ACA BOOKS
American Council for the Arts
New York, New York

WAITING IN THE WINGS

Brief excerpts from the following books appear courtesy the permission of their respective publishers: *The Joy of Music*, Simon & Schuster; *Museums for a New Century*, American Association of Museums; *Performing Arts: The Economic Dilemma*, Twentieth Century Fund; *The Performing Arts: Problems and Prospects*, Rockefellers Brothers Fund and McGraw-Hill Book Co.; and *Subscribe Now!*, Theatre Communications Group.

Copyright 1987 Bradley G. Morison and Julie Gordon Dalgleish

No part of this publication may be reproduced by any means without the written permission of the publisher. For information, contact the American Council for the Arts, 1285 Avenue of the Americas, 3rd Floor, New York, NY 10019.

Edited by Bruce Peyton
Book and Jacket Design by Celine A. Brandes, Photo Plus Art

Director of Publishing: Robert Porter
Assistant Director of Publishing: Karen Severns

Library of Congress Cataloging in Publication Data:

Morison, Bradley G.
 Waiting in the wings.

 Bibliography: p.
 1. Arts audiences—United States. 2. Arts and society—United States.
I. Dalgleish, Julie Gordon. II. Title.
NX220.M6 1987 700'.68'8 87-940
ISBN: 0-915400-53-7
ISBN: 0-915400-54-5 (pbk)
Printed in Canada

MAIN LIB.

NX
220
M6
1987

This publication was made possible
in part by the generous support of the
Shell Companies Foundation

*This book is dedicated
to all the dreamers and doers
who have committed themselves passionately
to the vision
of making artists and art
more central to our society*

CONTENTS

ACKNOWLEDGEMENTS

The information, case histories and stories which fill this book came from hundreds of helpful people around the country, and citing them all by name would be an impossibility. But our gratitude compels us at least to acknowledge them anonymously. They include some 463 audience development and marketing directors of arts institutions who took time to complete a questionnaire about their special programs to help adults learn about the arts. Dozens of our good friends and colleagues in the arts world supplied background, anecdotes, opinions and leads without which it would have been impossible to weave the total fabric of the work. And the staffs of many organizations and institutions were extremely cooperative in giving us access to facts and statistics when we needed them. But five people deserve personal acknowledgment for their very special contributions to *Waiting in the Wings.*

Robert Porter, director of publishing for the American Council for the Arts, who encouraged us to undertake the project, then stood by us patiently, offering helpful advice as we struggled to bring a semblance of order to something originally bordering on chaos.

Bradley B. "Buzz" Morison, who effectively carried out a variety of research over two years and then had the tenacity to wade through the first, lengthy draft of our manuscript with his editing pencil, teaching us the difference between "which" and "that" in the process.

Joseph Wesley Zeigler, consultant, colleague and friend, whose knowledgable counsel, wisdom and incisive but gentle critique of our work proved critical in giving final, cohesive shape to the book.

Bruce Peyton, a playright assigned to edit the last draft of our manuscript, who not only did it very effectively, but with a sensitivity and understanding of the ideas and philosophy that left our egos intact.

Danny Newman, consultant, friend and evangelist, who not only provided us with fascinating and helpful information and stories for this book, but over the years has provided inspiration to us and thousands of others with his fierce dedication and passionate caring about artists and audiences.

To all who guided, assisted and inspired us, thank you.

Bradley G. Morison

Julie Gordon Dalgleish

ACT

THE PAST

ONE

REVOLUTION UNREALIZED

"It was nine o'clock in the morning," he said, shuddering as a dancer would at the thought of the early hour. "It was our first performance—on our first tour—and it began at Frostburg State Teachers College in Frostburg, Maryland."

Thirty years had passed, but this dancer hadn't forgotten a single detail of that first touring performance. He began to spin a tale that had all the romance of the early days of a love affair. A choreographer, six dancers and a stage manager made up the troupe, and they had nothing. Nothing but a dream and a

vision, a borrowed Chevy station wagon and a U-Haul trailer. In 1956, that was enough.

"We unloaded the station wagon the previous day, set the stage, ironed our costumes and got everything ready for the performance. By nine we were warmed up and ready to go. The first piece we did was called *Within Four Walls*, with music by Stephen Foster. There were songs in this piece, and the six of us had to do the singing as well as dance. We'd have to go offstage and sing through a megaphone. We only had one, and at times we'd have to try to get two mouths on it. And then John, one of the dancers, would have to jump down into the pit to play the piano and then come up again to dance his role."

The six dancers and stage manager set off on tour, leaving the director/choreographer home teaching classes for twenty-five cents a person to meet the company payroll. The seven did everything—set lights, made costumes and pulled the curtain. Based in New York City, the company had been called by Columbia Artists Management to help fill dates in 23 Southern cities where concerts had been cancelled by another dance company. They were thrilled!

At least 600 students attended the performance in Frostburg, off in the Appalachians in the Maryland panhandle. "We wanted to bring *dance* to them—American dance. We truly believed we had a mission—a belief in the vision of American dance and what we could do for it. We wanted to conquer our own country!

"On the tour in one of the cities, we were in one of those old college auditoriums, and the proscenium was very low," he remembered. "We would do a high lift and half the ballerina would disappear. And the backstage toilet—it looked like an electric chair. It was surrounded by all the wiring for the lighting, and we had to be careful not to be electrocuted."

The young dance company had been working in an old converted necktie factory in New York at 430 Sixth Avenue. Other dancers, choreographers and composers had studios in that same building, including Louis Horst and Doris Humphrey. Merce Cunningham was on the floor above. "It was a communal affair, and we all helped each other. We were reaching out for each other. It was the way we all survived—we communicated and took interest in each other's art. I remember the time we gave our studio to Lotte Lenya free-of-charge to rehearse *Three Penny Opera*. We had no grants, no scholarships—we were independent artists who provided for each other."

Remembering more of the Frostburg engagement, he told about

2

breakfast following the performance. "Breakfast! Not lunch! We went to the campus cafeteria with around 150 students. After breakfast, a kind of seminar started—spontaneously. It happened naturally, and we discussed dance. We spent at least two hours talking with them. We found that they had never seen a pair of pointe shoes. They wanted to know when and how a dancer began. It was revealing to us; we were preaching the gospel of dance! We thought we were the best thing to happen to that college."

He described his troupe as evangelists who had set out to take dance to audiences across the country. And that 23-city tour in the borrowed station wagon and the U-Haul trailer was only the beginning of what is now a 30-year love affair with audiences. "They need to be revered and respected," he said. "They need to be loved and nurtured and developed."

Nurturing and developing audiences was their mission, the dancer said. And after touring 23 cities, they still believed. "It was a humorous and wonderful experience and afterwards we were exhilarated. Not tired. Exhilarated. It was a new adventure, and we couldn't do enough for our audience."

The dancer who remembers so vividly is Gerald Arpino. The choreographer who stayed home was Robert Joffrey. And the company they still lead—the one that played Frostburg, Maryland on the very first date of their very first tour in 1956—is now one of America's great ones, with homes on both coasts, The Joffrey Ballet.

It exploded on the scene like a mid-century revolution! Driven by the passion of dreamers and doers like Joffrey and Arpino, the arts in America responded to dramatic and deep-rooted changes in the social, economic and technological fabric of society and plunged into an era of unprecedented expansion.

Triggered by the emergence of a new majority with discretionary time, energy and money...propelled by a generation of idealists and visionaries whose creative energies had been diverted for the duration of World War II . . . and fueled by the largesse of a new breed of bureaucratic and institutional patron, the cultural life of the country burst free of its traditional bastions on both coasts and flew off in all directions, depositing art, artists and arts institutions in improbable places from Bumblebee, Arizona to Caribou, Maine. During the decades of the 1950s, 1960s and 1970s, more activity called "art" was made accessible to more people in more places than ever before in a phenomenon widely labeled a "cultural boom."

The battle cry of the revolution was sounded by a distinguished panel of 30 cultural leaders appointed by the Rockefeller Foundation, and it was recorded in their 1965 report, *The Performing Arts: Problems and Prospects*:

3

"The panel is motivated by the conviction that the arts are not for a privileged few but for the many, that their place is not on the periphery of society but at its center, that they are not just a form of recreation but are of central importance to our well-being and happiness."[1]

The panel supported its viewpoint by quoting Eric Larrabee, an author and educator who served from 1970 to 1975 as executive director of the New York State Council on the Arts. "In the eighteenth century," Larrabee said, "the question that preoccupied thoughtful people in the United States was the achieving of political democracy—and in the main we answered it. In the nineteenth century, the question was one of achieving economic democracy—and we answered that, too, at least in theory and in potentiality. In the twentieth century, the main challenge to the United States is the achieving of cultural democracy—but that remains far indeed from being answered."[2]

The Rockefeller Panel articulated a new challenge at mid-century, but along with the excitement of that new vision there came to the arts a new kind of "politicalization"—a need to *pay attention* to a multitude of forces in the society they were attempting to serve and were calling upon for support. It changed the way the arts did business.

HOW THE ARTS GREW

- In the ten years ending with 1975, 100 new professional theaters were established across the country, one-and-one-half times as many as the 40 that had been created in all the previous years.
- From 1970 to 1980 the number of major opera companies with budgets of more than $100,000 grew from 35 to 109.
- Between 1966 and 1985, the total number of museums in all categories increased by 28 percent.
- Dance exploded. The best available figures show that the number of companies increased by at least five times over two decades.
- Membership in the Association of College, University and Community Arts Administrators (ACUCAA), the largest service organization for presenters of performing arts attractions, increased from 29 in 1957, to 275 in 1966, to a total of 980 in 1985.
- During the 1960s and 1970s, seven regional arts agencies came into existence and brought performing and visual arts attractions to communities where there had been few, if any, previously. During its first ten years, the Mid-America Arts Alliance made more than 1,600 performing

4

and visual arts events available in 239 different cities and towns in Arkansas, Kansas, Missouri, Nebraska and Oklahoma, playing to attendance of nearly five million.

- *An explosion in the number of local arts agencies and councils took place. In 1949 there were two—in Quincy, Illinois and Winston-Salem, North Carolina. Today there are more than 2,000, of which at least one-third sponsor art shows and performances.*

As culture proliferated and decentralized, there were new pressures from new patrons and new communities, and a new need for the arts to reach out and embrace a more diverse public in order to achieve the dreams set forth for them. The old ways of hustling people into the circus tent and filling the opera house were no longer enough. The one-dimensional craft of old-fashioned press-agentry could not serve the new requirements of an exploding arts scene. More sophisticated techniques of promotion and commercial advertising were added to bring slick new dimensions to the concept of "marketing the arts."

Primary among the new techniques was DSP—the Dynamic Subscription Promotion principles of an evangelical Chicago press agent named Danny Newman. Annointed consultant by the Ford Foundation in 1961, Newman was dispatched across the land to preach the gospel of "the saintly season subscriber" and the "slothful, fickle single-ticket buyer" to America's performing arts organizations. In short order, DSP and its coveted goal of "selling out" to subscribers became the fundamental cornerstone of audience development.

For a while, the fresh ideas and new methods seemed to be working brilliantly. There was dramatic growth in total attendance for the arts across the United States. In community after community, new cultural activity found a strong initial base of public support, and euphoria was the mood of the day.

But as the 1980s approached, the expansion of the arts slowed substantially. New audiences ceased to enter into the nation's cultural life in the same numbers or with the same enthusiasm as they had during the "boom" of the previous three decades, and the growth in attendance seemed almost to come to a halt.

Today, in cities and towns where an initial base of artistic programming has been established, a reliable but small group of people continue to patronize cultural activity. But that group seems no longer to be growing. Existing data indicate that over the years audiences have grown as the availability of the arts has increased, but that in any developed community, the per-capita size and the demographic characteristics of that audience remain about the same as they were when the revolution began in the 1950s. The

5

arts, wherever they exist, still receive their basic support from the same relatively small crowd of affluent, well-educated people in the professions and managerial occupations who supported the nation's cultural activity before mid-century.

Has the revolution failed?

Possibly.

Little real progress has been made by the arts in moving from the periphery toward the center of society, and the achievement of cultural democracy is still only a dream. Movement toward both goals appears to have ceased.

Why is it that the growth of arts audiences has slowed and largely stopped? Are there simply no more people in our society who can be attracted to participation in our cultural life?

We are convinced that America has *not* reached the limits of growth for its arts audiences. Rather, the arts have reached the limits of what they can achieve with the current system of audience development *and* with the current perspectives about the roles and the goals of the arts in our society held by those who govern and manage them.

The central premise of the current DSP-based system of audience development is that new people can be attracted to participation in the performing arts through a package of varied events offered at a discount along with other benefits. DSP is supposed to motivate people to an *instant, long-term commitment* to the life of an arts organization, and the benefits reaped from this kind of commitment are enormous: "up front" money, a guaranteed audience, cost-efficiency and the opportunity to program adventurous works along with the traditional.

In the beginning, the DSP-based system worked wonders and built a substantial audience base. That base, however, is made up largely of people already predisposed toward the arts. We call them the *Yeses*.

Unfortunately there aren't many of them, and the supply is nearly exhausted. To keep their audiences growing, the arts must try to reach a larger group of people *not* as predisposed to or as comfortable with the arts—people who feel they "don't know enough" to be able to enjoy them. We call them the *Maybes*. They are a new breed of audience.

The arts are trying to force this new breed of Maybe audience into a ticket-selling system that primarily benefits the organization rather than the potential customer. The Yeses went along with it, but the new customers aren't buying.

As long as institutions insist on sticking with that system, they will be stuck on a plateau of attendance growth. Only when they acquire the foresight and courage to adapt the system to meet the real needs of a new breed of audience will the arts begin to move ahead again.

We believe the system that can attract the Maybes is one that recognizes their need to be *nurtured* from a first, tentative venture with the arts

6

through a continuing series of "stepping-stone" experiences leading eventually to total commitment.

This book is about a system which can do that. We call it SELL—Strategy to Encourage Lifelong Learning. We say: SELL now! Subscribe later!

SELL is a new way of seeing the separate elements that make up the present, overall system of audience development. It does not abandon subscriptions, but integrates them in a fresh way into a contemporary strategy that meets the needs of a new breed of audience. It does require a major commitment to a new dimension in audience development—the creation of imaginative programs of lifelong learning.

(Throughout this book, we will be using the phrase "audience development" in its broadest possible interpretation—as an "umbrella" term to encompass all aspects of promotion, publicity, marketing, public relations, communications and educational programs.)

We are convinced that SELL can move the arts ahead again in their quest for a larger, more democratic audience. But by itself, SELL is not enough. In addition to this fresh approach to the system of audience development, there must also be a change in the perspectives of those who govern and manage arts institutions.

The system we propose is a demanding one—demanding of creative talent, of time and energy, and of financial resources. Implementing it will require an investment of imagination, manpower and money far greater than that being made today to bring artists and audiences together. But that investment will *not* be made if we continue the current pattern in which the arts are expected to justify their existence by serving practical purposes and to maximize earned income with little regard for artistic or social consequences. It will not be made if the primary purposes of the arts are seen as economic development, tourism, corporate image and community prestige, or if the goals of governance and management focus primarily on safety, soaring sales, earned income, stability, status quo and survival. It will not be made unless all of us who work in the arts return to the real reasons for the pursuit of artistic dreams.

We believe the arts can move ahead again toward the achievement of cultural democracy. But this will require a return to the boundless visionary zeal of those like Joffrey and Arpino who launched the cultural revolution three decades ago. It will not be made unless all of us who work in the arts recommit our beings to the visions of our artists and our energies and resources to sharing those visions with audiences—no matter what the sacrifice. It will need a rebirth of passion *and* a thorough and sensitive understanding of the forces that have brought the arts to their present plateau of growth.

7

THE POLITICALIZATION OF THE ARTS

It was a gray winter afternoon in Rochester, Minnesota in 1961. Oliver Rea settled himself at the back of the living room of a large, handsome 1920s house where some of the city's most prominent citizens had gathered for a cocktail party. He watched the hostess flit about trying to settle everyone down for the main event—the introduction of Sir Tyrone Guthrie, who was to tell them about the theater he proposed to create in Minneapolis.

Rea was a young, New York producer who had set out with Guthrie and a production stage manager named Peter Zeisler to

establish a major, professional repertory theater away from the influences of Broadway. The plan had been hatched round the fireplace in Guthrie's farmhouse in Ireland just over 18 months ago. Since then they had visited seven cities that had expressed interest, finally settling on Minneapolis for reasons Guthrie described as "mostly hunch." Even Rea admitted that they were flying by the seat of their pants now as they barnstormed the Upper Midwest seeking financial support.

At last the hostess succeeded in getting everyone seated and then gave an appropriately flowery introduction for a knight of the British Empire, concluding with a description of Sir Tyrone as the best-known director in the English-speaking theater. Tony, as he was called by his friends, strode to the front of the room and climbed several steps of a stairway from which his six-foot, three-inch frame towered even more imposingly over the gathering.

Rea winced as Tony began his usual litany of charming insults. Without a truly great theater performing the classics, you really can't call yourselves cultured out here in the hinterlands, he would begin, going on from there to promise salvation to the unwashed if they would provide financial sustenance. In his eloquent and charming Irish way, Guthrie would spin out the vision of his theater and ask for support. The vision that the three men had concocted in front of the fire in Ireland was rather vague, as Rea recalled it. But Tony always made it sound quite substantial.

The one constant in Tony's description was that their theater would perform only the classics. "Only those plays will be chosen that have seemed, to discriminating people for several generations, to have serious merit," he would say. "That have, in fact, withstood the test of time." Fifty years was the absolute minimum age he would accept.

Suddenly Rea was startled from his Irish reverie. Tony was suggesting Arthur Miller's *Death Of A Salesman* as a possible choice for the first season. It was the first time Rea had heard him mention the play. And now he was going on about occasionally selecting American plays of "potential classic stature." The vision was being changed in midstream, Rea thought to himself.

Guthrie finished his presentation with appropriately inspiring language. His audience applauded enthusiastically and clustered around the towering knight to congratulate him and ask questions. Rea concluded that once again the charming insults had worked. He had observed that only about one in ten people were even mildly affronted, and he could put up with that.

10

When he found an opening, Rea sidled up to Guthrie and asked him about the sudden shift in artistic policy. "Well, dear boy," said Guthrie, "this quite charming gentleman came up to me beforehand and said *Death Of A Salesman* was his favorite play and would we ever consider doing it. And I decided maybe we could do American plays of potential classic stature on occasion. Don't you think that would be all right?"

Rea laughed aloud and looked up with affection at the man with whom he had been "stumping the territory" the past few weeks. "Tony, we really are peddling snake oil, aren't we?" he said.

Even as recently as 1961, an artist such as Sir Tyrone Guthrie could contact personally most of the people he needed to provide financial support for his dreams. "I have a vision," he was saying. "Trust me and give me your money." There was no spiral-bound long-range plan, no computer-generated budget. The magic of his face-to-face appeal was far more powerful, even though it seemed to Rea at times that they were peddling snake oil.

Guthrie asked for the patrons' trust in his somewhat ad hoc enterprise, and they "bought in." On May 7, 1963, the Tyrone Guthrie Theater opened in Minneapolis with *Hamlet*.

But times were changing. A revolution in financing the arts was already underway, and today it seems doubtful that even an eloquent knight of the British Empire could charm funds from the new breed of institutional and bureaucratic patron by saying only "I have a vision, trust me." In years long gone by, one or two wealthy individuals could underwrite an entire cultural enterprise and fulfill the dreams of the artists single-handedly. Personal communication and a bond of mutual trust made it happen. Often the commitment of the patron was based far more on passion, ego and whim than on the practicality, reason and logic now required.

The emergence of the new breed of arts patron in the 1960s and 1970s had profound effects on the way cultural institutions did business and attempted to promote themselves. Since it strongly influenced the development of a new system of audience development, it is important to understand the radical changes that took place in America at mid-century and caused this dramatic revolution in patronage.

The dazzling explosion of technology has been the most pervasive influence on Western civilization in the twentieth century, dramatically reshaping America's cultural life, directly and indirectly. The impact of motion pictures, radio and television on the arts and on the way we live—and see—our lives has been profound.

But three other significant changes in society resulting from the tech-

11

nological revolution made an equally formidable impact on the arts: the emergence of a majority of the population with discretionary time; the rapidly accelerating cost of the arts; and the dissipation of traditional sources of financial support.

Following World War II, America became a society unique in the history of civilization. For the first time, the majority of a nation's population did not have to expend all of its energy on survival—on the basic needs of food, clothing, shelter and reproduction. For the first time, there were more people in a society who had discretionary time and energy than did not. While some still live below the poverty line, they are the exception rather than the rule as they had been in all other times and places. The root cause of the phenomenon was the increase in productivity brought about by growing sophistication in technology.

Without historic precedents for guidance, the nation began a disconnected and frustrating search for productive and rewarding use of its newly available discretionary time, energy and income. "The first result of these changing conditions has been an emphasis on material acquisition and passive enjoyment," the Rockefeller Panel observed in 1965. "But there is a growing realization that simple materialism cannot permanently satisfy a society, that political and economic progress alone cannot satisfy spiritual hunger, that entertainment which makes no demand upon the mind or the body offers neither permanent enrichment of the spirit nor a full measure of delight."[1]

While the Rockefeller report seems overly optimistic in retrospect, the contentment with affluence and acquisition that characterized the 1950s began to lessen with the 1960s. Many people entered into a more active search for other ways to utilize their new freedom. It took many diverse and random directions, including active exploration of self-expression and self-individuation—a basic human need beyond the four requirements for survival. More people than ever before could and did turn toward artistic expression and became artists. More people than ever before could and did participate in the arts as audience members.

Across the nation there arose a demand for cultural activity beyond what had existed before the new affluence, and that pressure gave impetus to the decentralization and proliferation of the arts that began in the 1950s, grew dramatically in the 1960s and continued into the 1970s. It was the genesis of the "cultural boom."

But as demand for the arts increased, they also became more expensive. While more sophisticated production techniques were driving the costs of tangible goods down, in comparison the cost of labor-intensive services was going up. Two professors of economics at Princeton University brilliantly documented the phenomenon for the first time in a pioneering study published in 1966. William J. Baumol and William G. Bowen, with

12

their book, *Performing Arts: The Economic Dilemma*, changed the nation's perspective on funding the arts.

Remarkable gains had been made in productivity, they said. New technology, an increasing capital stock, a better-educated labor force and the economics of large-scale production combined to produce a steady record of increases in output per man-hour.

In sharp contrast, the live performing arts had not shared in this growth of productivity, nor, by their very nature, would they ever. They are "technologically stagnant," Baumol and Bowen observed. The work of the performing artist is *an end in itself*, not a means of producing goods. Substantial changes cannot be made in the method or efficiency of operation. The live performing arts cannot be automated like an assembly line.

They then wrote a paragraph destined to be quoted repeatedly in the decades ahead as primary justification for increasing subsidy of the arts:

"Whereas the amount of labor necessary to produce a typical manufactured product has constantly declined since the beginning of the industrial revolution, it requires about as many minutes for Richard II to tell 'his sad stories of the death of kings' as it did on the stage of the Globe Theatre. Human ingenuity has devised ways to reduce the labor necessary to produce an automobile, but no one has yet succeeded in decreasing the human effort in a live performance of a 45-minute Schubert quartet much below three man-hours."[2]

The live performing arts, they concluded, were destined to continue becoming relatively more expensive, developing ever-widening gaps between earned income and expenses.

These economic facts of life, coupled with increasing demand for the arts, were bound to create significant problems. But yet a third major socio-economic change was taking place, compounding the difficulties to the point of major crisis and leading, ultimately, to a revolution in the way the arts did business.

The traditional source of financial support for the arts—the great wealth of individual patrons—was drying up.

Throughout the history of Western civilization, kings, princes, dukes, other nobility and merchants of wealth were the central patrons of great art. During the Middle Ages and the Renaissance, the Church became a major source of largesse as well. At times, the state bestowed support upon artists, and in Europe during the past century, the state has become a primary patron. But in the United States, wealthy individuals were the backbone of patronage, and this tradition continued through the settling and maturing of our country.

In the early nineteenth century, this munificent class consisted largely of wealthy merchants, financiers or men of inherited fortunes; but with the explosive industrial growth after the Civil War, business entrepreneurs built

13

incredible fortunes with breathtaking speed and soon became the ruling patrons of the arts. Author Alvin Toffler calls them the "tycoon-patrons." The Morgans, Rockefellers, Carnegies, Pulitzers, Mellons, Fricks, Corcorans, Guggenheims, Havemeyers, Higginsons, Hearsts and dozens of other millionaires like them became the new American Medicis.

But their days were numbered. The dissipation of the great individual fortunes was probably most stimulated by the first income tax legislation in 1913. In 1922, the Internal Revenue Service detected a decrease in the share of the nation's wealth held by a handful of rich people, a trend which has continued steadily into the 1980s. Wealth in the United States was being redistributed. Some was going to the middle and upper classes; but much was being transferred to the control of corporations and foundations. People with fortunes large enough to support major arts institutions single-handedly were disappearing.

As the nation reached mid-century, an unprecedented expansion of arts activity—and rapidly escalating costs—made it necessary to reach out to far more sources for financial support. At first, this was simply a matter of communicating with *more* individuals of wealth. For a time, artistic leaders could still make direct contact with most patrons, communicating visions face-to-face, stirring passion with personal charisma. Even as late as the early 1960s, Tyrone Guthrie could talk personally with most of the individuals and organizations who contributed the $2.2 million to finance his new theater. But it would have been beyond even his enormous energies to meet each year with all the contributors now necessary to provide annual operating support for the same theater.

The Boston Symphony Orchestra provides a dramatic example of the enormous expansion in the number of supporters needed to maintain a major arts institution. For 37 years—from its founding to the end of World War I—financier Henry L. Higginson was the orchestra's *only* patron. Today that institution depends upon the annual contributions of more than 10,000 different individuals, corporations, foundations and government agencies.

As the number of individual patrons required to support an arts institution grew beyond the capability of its artistic leader to make personal contact with all of them, fundraising responsibilities fell to the board of trustees. In the beginning, they turned to *their* friends, with whom there was already a bond of trust, and said: "I know an artist who has a vision. Give me your money, and I will give it to my artist friend to use to create art."

When it became necessary for board members to look *beyond* personal friendships for funding, they discovered that trust was a much less useful tool for gaining the commitment of new contributors. Reason and logic began to replace friendship and passion.

14

In the 1960s and 1970s, with both demand and costs continuing to rise, the arts were forced to look beyond wealthy individuals for support. They had to seek funding aggressively from two sources largely untapped until then—business and government. Ultimately, this would bring about fundamental changes in the way the arts did business, in the way arts presented themselves to the world and, to some degree perhaps, in the way the arts made art.

Generally, government had had more experience in cultural activities than the corporate sector, largely through the Works Progress Administration (WPA) Arts Projects during the Depression of the 1930s. With the economic collapse of 1929, private patronage of the arts had halted abruptly, forcing symphonies, theaters and opera companies to close their doors, sending musicians, actors, writers and artists to the bread lines, and confronting the nation with a question: Are the arts mere luxuries to be dispensed with in hard times? The answer from the administration of Franklin D. Roosevelt was a decisive no. America's creative artists were not to be treated as expendables. In 1935, Congress created four Arts Projects as part of the WPA, and within six months, more than 40,000 people had been hired to develop the projects in music, theater, writing and art.

With World War II came the end of the WPA programs, and when "normalcy" returned to the country in the late 1940s, the federal government abandoned the concept of support for the arts as something necessary only in time of economic depression.

In the 1950s, as the economic crisis within the arts became more evident, new calls were heard for government assistance. By 1959, Senator Jacob K. Javits (R-NY) was proposing a federal foundation to stimulate artistic achievement, but it was not until 1965 that Congress created the National Council on the Arts, triggering the rapid development of state and local arts agencies and an impressive growth in the financial participation of government in the arts. From an estimated total of $5.2 million in 1966, federal and state appropriations for the arts were increased by more than 57 times to a total of $298.6 million in 1984.

Unlike government, American business had paid little attention to the arts prior to the 1960s. The 1965 Rockefeller Panel report noted that "the typical American corporation has so far shown very little enthusiasm for support of the performing arts" and estimated that in 1963 business contributed a total of only $16 to $21 million to the arts.[3] According to current estimates of the Business Committee for the Arts, total arts giving by American corporations and businesses in 1987 will be *15 times that amount* in constant 1963 dollars.

As the 1970s approached, corporations and government were becoming the dominant funders of the arts. And the rules of the game were beginning to change. The funding decision-makers in governmental and corpo-

rate bureaucracies were far removed from the makers of art. No longer could trustees, managers and artistic leaders of cultural institutions deal primarily in visions and dreams, faith and trust, magic and personal charisma in cultivating supporters. No longer could passion serve as justification for the support of art. Unlike the old "tycoon-patrons," the new "bureaucrat-patrons" had large constituencies to satisfy. They had different goals and did their business in a different way. The existence and needs of the arts would have to be justified with arguments and language that business and government—and stockholders and voters—could understand.

Before checks could be issued, the new patrons needed reason and logic, facts and figures, and strong proof of practical results. They asked that magic be described in proposals, that dreams be fit into boxes on forms. Visions had to be Xeroxable. The charisma and eloquence of a Tyrone Guthrie were irrelevant, unless they could be translated into spiral-bound plans and computer-generated budgets.

The arts were being politicized through a process by which the new bureaucrat-patron sensitized the artists, managers and trustees to the needs and demands of a broader, less personal and more pragmatic constituency. The arts were being asked to be "businesslike," and this turned out to be a mixed blessing.

WAITING IN THE WINGS

THE BUSINESS OF BEING BUSINESSLIKE

A brisk November wind swirled dust, a dance program and a shredded page of *Variety* around his feet as Brad Morison turned off Columbus Avenue and ducked down the stairwell to the stage door of the New York State Theater in Lincoln Center. Through the double glass doors he found the guard and indicated he was there for an appointment with Betty Cage of the New York City Ballet. He would call upstairs, the guard said, and see if she was in.

While he waited, Morison perused the company photos mounted

on the long wall next to the elevators. Toward the end, he ran across some shots of the New York City Opera, which shared the theater. It was 1970, and the two institutions also shared a common administration—the New York City Center of Music and Drama, an umbrella organization that had helped nurture both companies into prominence at the old City Center Theater on West 55th Street.

"Miss Cage is in a meeting," the guard announced. "But they say she'll be out in a few minutes."

Morison nodded a thank-you and turned back to the pictures. He had just come from the offices of the City Center organization, and it had been a frustrating visit. He was working on a project for the New York State Council on the Arts that required collecting budget information from some of the state's major performing arts organizations.

The Council had received an unanticipated windfall that spring in the form of an increase in annual state funding from $2.0 million to $18.0 million. The Legislature had called it a one-time, emergency appropriation and prohibited the Council from adding staff to cope with giving away ten times more money. But with no precedent or guidelines to go by, the Council had retained Morison's firm, Arts Development Associates, to analyze and interpret the financial problems of the Council's larger constituent organizations so that grants would bear some relationship to real need. Morison's assignment was to find out how much money the New York City Ballet spent, how much they earned in ticket income and how much subsidy they required, and then to do the same for the New York City Opera. The City Center organization hadn't been much help. They kept only one set of books and didn't differentiate between the two companies. Everything was lumped together in what Morison thought of as a very "squishy" set of books. You poked around in one place, and something popped up in another. When he couldn't find what he needed, the City Center staff had referred him to Betty Cage.

The elevator doors opened, and a young woman announced that she would take him to Miss Cage's office. Almost from the day she arrived on the scene in 1948, recruited from the Gotham Book Mart, Betty Cage had borne the rather nebulous title of General Administrator, and she held that title until the day she retired in 1984. She was obviously important to the organization, Morison thought, as he was ushered into an office on the fourth floor right next to one labeled "George Ballanchine." Certainly *she* would be able to give him the financial information he needed.

18

In a moment she slipped into the room, short, slight, smiling and eager to help. Morison explained his problem. "At the very least, I need to find out how much money the Ballet spends in a year, and how much you take in at the box office." Betty Cage's smile turned into a slightly bemused expression. "Ideally," Morison continued, "I'd like to know how much it costs you to mount a new work by Mr. Ballanchine, for instance, and how you amortize those costs over a number of seasons." The bemused expression became what looked to Morison like something approaching horror.

"Oh, Mr. Morison," Miss Cage said, "we don't have anything like that at all. You see, City Center keeps all our books."

Morison indicated that he had just come from looking at those books. "It doesn't have to be all neatly laid out and perfect," he said. "If you just have any kind of records that I can go through to get some idea of what your costs are, that would be fine."

"Well, maybe I do have something that would help," she said and disappeared out the door and down the hall.

Morison wiled away a considerable amount of time reading ballet programs and examining the photos on the wall. Finally, Miss Cage slipped back into the room, her arms loaded with Capezio shoe boxes.

"I had to go clear down to the basement to get these," she said, setting them down on the desk. "But they might be what you need." She took the lid off one of the boxes. "I'm not quite sure what year this is, but maybe these will help."

The Capezio box was full of little packets of check stubs, bills and receipts, neatly bound together with rubber bands.

When the new bureaucrat-patrons from the worlds of corporations, foundations and government began to come to the aid of the arts in the 1960s, they encountered business management practices which usually mystified, frequently startled and sometimes appalled them. Betty Cage's shoe boxes at the New York City Ballet were infinitely superior to some of the systems, or non-systems, with which many smaller and less-established arts institutions were trying to make do at the time. It was little wonder that the new breed of funders quickly made it clear that they wanted the arts to demonstrate greater fiscal and managerial responsibility—to be more "businesslike."

In *Performing Arts: Problems and Prospects* (1965), the Rockefeller Panel pointed specifically to the need for arts organizations to improve their administrative practices and demonstrate responsibility, continuity and the promise of some stability if they were to attract major new sources of fund-

ing. "Even foundations that might be inclined to support the performing arts complain that arts organizations characteristically ignore the financial facts of life, are frequently careless in their managerial procedures and expect to be supported without providing a plausible projection of future expenditures," the report said. "Unquestionably, many groups should make a greater effort to put their houses in order before seeking outside support."[1]

So haphazard were some of the practices discovered by potential funders in their initial explorations of the managerial state of the arts that many concluded that—even without new contributions—major financial problems might be eliminated by the application of more effective administrative and fiscal management systems.

Although it now seems nearly impossible to believe, the prevailing wisdom among many arts leaders and patrons in the early 1960s was that the performing arts—particularly resident professional theater—should eventually be able to sustain themselves on box office receipts alone, to "break even" without annual contributions.

Among the earliest believers was the Ford Foundation. In its 1962 annual report, Ford explained an expansion in its program in the arts as "an attack on the institutional problem impeding progress and professional practice of the arts in the United States" and reported grants to nine resident professional theaters that had as their aim "to help the participating theaters ultimately sustain themselves through box office receipts."

The report of the Rockefeller Panel in 1965 indicated a similar view. "There is reason to expect," it stated, "that more of the nonprofit permanent professional theaters, as they become better known and better established in their communities, will be able to make ends meet in some years with box office receipts and still fulfill their special artistic obligations."[2]

The optimism of the times about theater spilled over to the other performing arts, and many of the programs, projects and experiments of the day were devoted to finding ways of achieving that goal. Most of them were guided by the general notion of making the arts more "businesslike," with specific initiatives launched on two fronts: (1) improving administrative and fiscal management personnel and practices and (2) being more aggressive and sophisticated about selling tickets in order to build a strong, permanent base of audience support.

Before the unprecedented expansion of the arts after World War II, promotion of art and entertainment in the United States was one-dimensional. It consisted of old-fashioned "press-agentry." In the days when newspapers flourished as the only means of mass communication, romancing the press to get stories printed was all that was necessary. The ability to devise and sell outrageous publicity stunts to gullible (or sometimes willing) reporters and editors was the measure of a press agent's skill, and tales of their exploits in show business are legion.

20

New York City was the hub of entertainment and art, and America took its cues from Broadway and from 57th Street, the centers of theater and music. Broadway press agents used newspapers to create stars, and stars sold tickets. Plays went on tour and local press agents exploited the stars in local papers to fill their houses. The great impressarios of 57th Street such as Sol Hurok used the press to create legends like Pavlova, Jan Peerce and Artur Rubenstein for press agents elsewhere to use in selling out recitals and symphony concerts.

But the decentralized arts that began to proliferate across the country after World War II were taking the form of *institutions*. And whereas press agents concerned themselves primarily with individual events or artists, the new institutions were presenting many events within a season and many seasons within their lifetimes. To be sure, there had been cultural institutions around the nation before mid-century—primarily museums and symphony orchestras, colleges and universities that offered concert and lecture series, and some theatrical "road houses" that booked and presented their own seasons of plays. But they could exist largely on local publicity flowing from the magic of legends created in New York.

The new kinds of arts organizations, most of them resident companies, did not build their seasons around charismatic guest stars. Their presentations did not lend themselves to publicity stunts. The problems they faced seemed more like those of establishing a commercial product line or building a corporate identity, and the new breed of patron was quick to see the parallel. It was natural that the pressure on the arts to be more businesslike should go beyond administration and fiscal management to embrace the concept of augmenting old-fashioned press-agentry with contemporary sales promotion and marketing techniques.

The two-pronged effort to move the performing arts toward self-sufficiency was nowhere better exemplified than in the early efforts of the Ford Foundation. Under the relentless urging of W. McNeil "Mac" Lowry, Ford became the first major foundation in America to support the arts, and by the early 1960s was one of the most significant influences on the arts, their managements and their audience-building methods in the country.

A Ph.D. in English literature and an ex-newspaperman, Lowry came to Ford in 1953 to work on its education program. Two years later he became director of grants in the humanities and immediately began efforts to include the arts. By 1957 he had succeeded; and although his Humanities and Arts program granted only two or three million dollars in each of its first few years, the Ford Foundation and Mac Lowry had an impact far exceeding the dollar value of their largesse.

Lowry was a firm believer in the prevailing theory of self-sufficiency for the performing arts, and he expressed his feeling in both words and money. The first grant Ford made to the Guthrie Theater was for $337,000 for

21

pre-opening expenses and "to assist it for three seasons until it can become self-supporting at the box office." Although the Guthrie's Oliver Rea was skeptical of that goal and realized halfway through the first season that it was an impossibility, he knew Lowry felt so keenly about the concept that he "adjusted" the books for 1963 to show a $6,933.14 profit, "for Mac's benefit."

In addition to his support of the Guthrie, Lowry established two extremely influential programs designed to help performing arts organizations across the country reach the coveted goal of self-sufficiency. Better management was to be achieved by training better managers. A strong, permanent base of audience support would be attained by the Ford Foundation's endorsement and support of a system for selling season subscriptions developed by a Chicago press agent.

Lowry's Program for Administrative Interns was initiated in 1962. Although it lasted just eight years, it had a significant long-term impact on arts administration and, indirectly, on audience development methods. A total of $664,000 was appropriated by Ford to provide 75 individuals of promise with on-the-job experience and professional training in the administration of professionally-staffed theaters, ballet companies, opera companies and symphony orchestras in the United States. A 1974 evaluation indicated that the program had begun to fill an important need and had "created national awareness of the exigency for arts management training programs."

The Ford Intern Program had ended by the time of the evaluation. But the cause which it had championed was by no means abandoned. Rather the torch was passed to the nation's colleges and universities. While some of the earliest of the new graduate programs in arts administration, such as those at Yale and New York Universities, were developed within departments of the arts, many others were created under graduate schools of business. The first of these was begun in 1969 at the University of Wisconsin; concepts developed in this program (headed by E. Arthur Prieve) were influential in drawing academic experts in *marketing* to the arts across the country.

One of the faculty at Wisconsin was William Dawson, director of the Wisconsin Union Theater and of the fledgling organization that was to become the Association of College, University and Community Arts Administrators (ACUCAA). In surveying the way the arts did business, Dawson decided that the methods used to sell culture needed an infusion of new ideas and techniques. As a result, he sent out a call to university professors across the nation for papers on applying commercial marketing principles to the arts. A conference in 1978 and the publication of a book followed (*Marketing the Arts*, Praeger Publishers, 1980).

As practiced in the commercial world, the concept of marketing went

far beyond advertising and sales. Marketing took the whole process of *determining and/or creating consumer needs*, integrated it with *product design, packaging and distribution*, and applied highly sophisticated systems of motivational research, communications and sales to making the system work. E. Joseph McCarthy, in his book *Basic Marketing: A Managerial Approach*, defines commercial marketing as "the performance of those activities which seek to accomplish an organization's objectives by anticipating customer or client needs and directing a flow of need satisfying goods and services from producer to customer or client." It was largely through Dawson's efforts at the University of Wisconsin that academic marketing experts were encouraged to apply the techniques of commercial marketing to selling culture.

Soon the nation's arts management programs were turning out graduates fired with enthusiasm for marketing the arts, and their professors were busy pursuing consulting assignments in this intriguing new field. At the same time, as cultural institutions looked increasingly to business for financial support, more and more bright, young corporate executives were replacing wealthy individuals on boards of trustees. Their fresh ideas and high-powered management experience—often reinforced by masters of business administration degrees—brought modern methods and greater efficiency to administrative and fiscal control systems. Although the New York City Ballet does not yet have a sophisicated computer system for fiscal management, Betty Cage's Capezio shoe boxes have been replaced by steel filing cabinets.

Many of the new breed of trustees were fiercely dedicated to the principles of commercial marketing. They saw no reason why these principles should not be applied to the task of selling the art produced by the institutions under their governance. Often they encouraged managers to make connections in the commercial world with professional advisors and agencies specializing in research, public relations, advertising and marketing. Sometimes they helped recruit marketing and promotion people from business to fill similar positions in the arts.

By the late 1970s, marketing was the trendy buzz word in the arts. More and more, when the new breed of trustees got together with the graduate school-trained administrators, their talk was of consumer research, packaging, positioning, pricing, advertising, motivation, image-making, promotion and sales.

In the 1980s, the Stanford Research Institute (SRI) developed its Values and Lifestyles (VALS) system, which divides the population, according to values and lifestyle characteristics, into nine groups. SRI describes VALS as "a fresh approach to understanding why people act as they do as consumers and as social human beings." But although the concept was new to the field of marketing, its fundamental principle is not unlike the basic motiva-

23

tional theory used in advertising for many years. The idea is simply to tailor your selling message—in words, pictures and graphics—to the interests, needs and values of the people to whom you are trying to sell. In the arts, VALS quickly became a "hot item," but it seems to have had little impact, other than to make those promoting the arts aware of a long-accepted, basic principle of selling.

The new concepts of commercial marketing which began to be applied to the arts in the 1970s were not replacing press-agentry, but augmenting it; and, for the most part, they were being used to increase the effectiveness of another new concept which had become the cornerstone of audience development during the time of explosive growth. It was called Dynamic Subscription Promotion, and it achieved its prominence and influence largely because of the Ford Foundation.

Along with his efforts to improve arts management, Ford's Mac Lowry set out in the early 1960s to help the arts build a strong, permanent base of audience support. To deal with that problem, he found a more flamboyant solution than his Administrative Intern Program. He discovered an evangelical press agent in Chicago named Danny Newman and dispatched him throughout the land to preach the gospel of DSP, or the art of selling season tickets.

The arts were never the same again.

A BRAVE KNIGHT FIGHTING THE BATTLE

Fall in Chicago is a time of rapidly changing weather, from steamy hot to windy cold, a time when sickness can attack even the hardiest person. But, for 42 years, illness had rarely afflicted Danny Newman, a press agent of exuberant energy and a crusader for the performing arts.

In the autumn of 1961, however, Newman fell "deathly ill" with the flu on the day he was to leave for the first conference of American professional resident theaters, to be held in Washington, D.C. Throughout the week he had felt strangely about the

meeting; yet, despite the trauma of his illness, his premonitions told him he must get there.

He staggered to his office at the Lyric Opera of Chicago to prepare his speech and to clean up his work. By the time he finished, he had become so ill that he could hardly walk, and when a taxi arrived to take him to the train station, he had to have two friends carry him to it.

Two months before, he had received a letter from Pat Brown, acting director of the new Theatre Communications Group, requesting that he address the conference. He knew that the Ford Foundation's director of arts and humanities, W. McNeil "Mac" Lowry, had initiated the meeting and was funding it.

Lowry had learned of Newman's accomplishment of selling an "astonishing" number of tickets for the Goodman Memorial Theatre in Chicago. But he was especially impressed with the story of his work at the Studebaker Theatre, where, as legend had it, Newman sold 17,000 subscriptions for a theater company that didn't exist at the time, 1956—an era when arts organizations sold subscriptions in the hundreds, not thousands.

When Newman arrived at the depot, a porter helped him to his compartment, where he fell asleep before the train pulled out. He remained in bed for the 15-hour trip, and upon arriving in Washington, he awoke healthy—"perfectly and completely healthy." Certainly, he thought, this must be a sign of the significance of this meeting.

While getting a shave at the Washington depot barbershop, he began to think about the people who would be attending. "The Founding Ladies"—Nina Vance of Houston's Alley Theatre and Zelda Fichandler of Washington, D.C.'s Arena Stage—would be there along with leaders of the four other resident professional theaters and representatives of about 25 university and community theaters. His plan was to deliver a speech about the promise of subscription sales and to demonstrate their importance with stories of his successes at the Lyric Opera, the Goodman Memorial Theatre and the Studebaker.

From the back seat of a cab, Newman directed the driver to the Sheraton Plaza Hotel. As the taxi arrived, a strange feeling came over Newman—a kind of deja vu. He paid the driver and walked into the lobby. Suddenly, it began to dawn on him. He remembered, or seemed to remember, that the Sheraton Plaza had once been the Wardman Park Hotel, and that he had been there when it was. All at once it was clear. It had been 1937, when he was 18 years old; he had gone to Washington, to this hotel, to attend a meeting of the Confederacy of American Civic Theaters!

26

From that moment on, he was absolutely certain that the 1961 conference was going to be fateful for him, that it was going to be the turning point in his career.

That conference was indeed fateful, not only for Danny Newman but, eventually, for all performing arts organizations. One of the primary topics discussed there was subscription sales. Although those attending the conference had heard of subscriptions and some had sold them, the common belief in 1961 was that theaters should not even attempt to sell more than ten percent of their seats to subscribers. What Newman suggested was just the opposite. Theaters should be 90 percent subscribed. "Why are so many of you playing to such poor attendance? Start with the general philosophy that there will be no single-ticket sales—every ticket you don't sell by subscription, you're going to eat," preached this evangel of subscription sales.

Newman probably didn't sell everyone in his audience on his ideas about subscription sales. Most of the conferees returned to their homes enlightened by the discussions of the conference, but intending to continue business as usual.

Conference sponsor Mac Lowry, however, was sold. After hearing Newman speak, he began to believe, more than ever, that it might be possible for theaters to "pay their own way." Following the conference, he asked Newman to go to Houston. "Founding Lady" Nina Vance's professional resident company was in trouble.

Newman arrived in Houston in early 1962 filled with ideas for the Alley Theatre. In his first meeting with its leaders, he implored them to start a major subscription campaign—give away *at least* one play free and sell out on subscription. The business manager was stunned. He never gave any tickets away until "I know the play's a flop." But Newman's enthusiasm—and his philosophy—prevailed, and soon a full-blown campaign was underway. According to Newman, by the end of the fifth year of subscription sales, the Alley had sold 10,000 season tickets for a 225-seat house, providing the justification they needed for building a new theater.

The Washington, D.C. conference and the Houston adventure were the beginning of "Danny appleseeding," of spreading Newman's gospel of subscription sales to performing arts organizations throughout North America, Australia, New Zealand, the Philippines, the Republic of China, England, Holland and Israel. Within a few years, Newman's Dynamic Subscription Promotion (DSP) would become the cornerstone of audience development for the performing arts.

Newman sold his first subscriptions at the age of fourteen. A "child prodigy" press agent for the Mummers of Chicago, a civic theater group, he went "house to house, apartment to apartment, ringing doorbells and convincing those who dwelled therein to sign up for my season." He was a

27

zealous young man who thought of himself as a "brave knight fighting the battle for the lady fair." He later handled press relations for a "Wild Indian show," circuses and nightclubs, classical concerts, legitimate theater and vaudeville. He also boasts of being the publicist of the first Miss USA contest.

In 1945, he joined the Chicago Opera as press agent, but just a year later the company went broke. "It was the sixth opera company that had failed in Chicago since 1910, and I learned a tremendous lesson," he says. "No Chicago opera company had ever been subscription-oriented. Their idea of a subscription was to sell a box to a rich board member."

Following that experience, Danny Newman began to preach the importance of subscription to the survival of an arts organization. He was not the first, however, to embrace the subscription concept. Community Concerts, a division of Columbia Artists Management that develops series of performing arts events for small communities, had, in 1920, created and promoted what they called the organized audience movement. The movement's goals were to eliminate financial risk, ongoing ticket selling and the gamble of depending on single-ticket sales.

Community Concerts created associations as nonprofit membership organizations in small towns to sponsor concert series. The sale of memberships provided money for hiring artists, who were chosen according to the limits of membership income in any given year. Single admissions were not available, meaning only members were allowed to attend the concerts. In the same decade, the Theatre Guild, a New York producing and presenting organization, developed a subscription program for Broadway and later established the program in a number of other cities where Guild-sponsored road companies played. American symphony orchestras had developed their own subscription audiences using a system borrowed from central European orchestras.

Ward French, one of the originators of Community Concerts' organized audience movement, wrote in a 1945 report, "Why should we take the gamble on stormy nights, the public's whims, mistaken judgement, local competition, etc." Like other early cultural crusaders, French wanted to bring arts activity to cities across the country, but he believed that the arts should survive on earned income alone. He saw his organized audience movement as the only viable plan.

Newman, inspired by the success of French's pre-sold concert seasons, recognized that the concept held even greater promise for other kinds of arts groups. He began formulating his own concepts in 1954 when he helped Carol Fox, Larry Kelly and Niciol Rescigno found the Lyric Theater (now known as the Lyric Opera of Chicago). He was hired as a press agent, but he became, he explains, "like a surgeon retained to take out your appendix who looks around inside and finds other things to do." Looking

28

beyond press-agentry, he decided to develop a subscription program that would make the Lyric Opera productions immune to critics and weather. The results of his efforts were remarkable; within a few years, the Lyric Opera was on firm ground and building steadily toward its current position of national and international renown.

Three years later, Newman also joined the staff of the Goodman Theatre at the Art Institute of Chicago. Until that time, the theater had been a showcase for drama school students, but John Reich, the Viennese stage director, was brought to Chicago in 1957 from his work in the New York theater and Hollywood to make the Goodman a professional repertory company. With Newman's help, the Goodman's annual subscription sales rose from 1,800 to 18,000 in a decade.

When Newman addressed the 1961 theater conference in Washington, his accomplishments at the Lyric Opera, his launching of the Goodman's successful subscription campaign, and his legendary work for the Studebaker Theater were all behind him. Ahead was a 20-year assignment as audience development consultant for the Ford Foundation, Theatre Communications Group and the Canada Council.

Since 1961, Newman has been delivering his message and extending his energy to symphony orchestras, theaters, dance companies and even some museums. He packaged his concepts in his Dynamic Subscription Promotion (DSP) system, which is based on Newman's conviction that every arts organization must aim to sell out on subscription for three primary reasons. First, subscriptions provide financial security. Second, the institution has a solid base of audience for every production, no matter how adventurous. Finally, organizations can save money by selling tickets just once at the beginning of the season.

In Newman's book, *Subscribe Now!*, he exalts the "saintly season subscriber" who invests his money in advance of the season, expressing a firm commitment to the organization. The subscriber is loyal. He understands the rights of the arts institution to experiment and is not influenced by excuses such as the weather and critics.

The arts must beware, Newman warns, of the "slothful, fickle single-ticket buyers." He deems them unreliable. They can't be counted on if the weather is too cold or too hot, or, if it's a beautiful day, they may claim that they must be outdoors, "in communion with Nature when it smiles on Man." Bad reviews will keep them away; so will good ones, if the single-ticket buyer feels that the critic doesn't know what he's talking about. The unexpected appearance of out-of-town guests, weariness at the end of the workday, not being in the right mood—almost anything will serve as an excuse for not attending. When *do* these people buy tickets? According to Newman, only when a show is a hit or on the "occasion of their 25th wedding anniversary."

29

Not only are these people unreliable, but they are also impatient with the arts' need to experiment and try new work. The single-ticket buyer "picks all the raisins out of our cake" and avoids adventurous or experimental programs.

The "saintly season subscriber," on the other hand, is not influenced by weather or critics or other opportunities that may interfere. He understands the artist's need to present new works or those of an obscure nature. He will "take his punishment in good spirit and, in most cases, won't hold it against us at renewal time if we let him down or if he doesn't like a work."

Newman seeks out this paragon of loyalty through what he calls "artillery and infantry." The artillery is publicity. The infantry is the follow-up: the massive mailing of brochures, endless tea and coffee parties, telephone calls, volunteers going door-to-door, discounts, block sales—anything and everything it takes to make the sale.

The extensive mailings and big discounts are central to Newman's campaigns. He believes that "if we attack dynamically enough and massively enough, we can win a vast new audience at once, eliminating unnecessarily wasted years."

In a large market, a typical Newman brochure may be sent to as many as seven or eight hundred thousand homes in two mailings. He collects names and addresses from every arts organization in the community and finds lists of doctors, lawyers and any others he feels would be appropriate. He implores boards of trustees to share their Christmas card lists, and then sends brochures to every board member's friend and business associate.

His brochures hail discounts of up to 50 percent, displaying in large capital letters the words FREE, DISCOUNTS and BENEFITS. The reader may find that he'll receive "6 1/2 Plays Free" if he will "Subscribe Now!" The brochure gives a list of subscriber benefits, not the least of which is the privilege of joining the "aristocracy of good taste," the favored circle of the sophisticated and discriminating. The critical seal of approval is bestowed on the company by quotes from rave reviews. Newman exhorts the potential buyer to join, enjoy, share, have, develop and take.

Newman's own descriptions of plays, operas, ballets and symphonies are legendary. His sexy, provocative copy is designed to entice and seduce. Of *Aida*, he writes: "Here is the sweep and grandeur, the pomp and pageantry, the thrilling spectacle, the soaring of mighty orchestral power, the overwhelming outpouring of melodic magnificence—as decadent imperialism enslaves a proud African leader and tragically blocks his beautiful daughter's marriage to the Egyptian general—against the exciting background of Egypt's exotic pagan idol worship. The crown jewel of the Verdian opera diadem."

30

Bertolt Brecht's *Baal* is, in Newman's words, a "hop-head, lush, lecher, killer—and he's the raffish, roistering, rooster-protagonist of this sensational, seminal play that set the stage for all the bitter, bawdy, mocking, shocking, jeering, jarring Brechtian epic theater spectacles that followed."

Newman supports the brochures with other Dynamic Subscription Promotion techniques. He encourages telephone sales, neighborhood coffee parties, block sales to businesses and other groups, and even door-to-door selling.

He writes in his book that, although arts organizations "have admittedly gained these greatly enlarged audiences by the 'artificial' stimulation of their successful promotional efforts, once those audiences have jammed their performances or participated in their programs all season long, their new positions of strength are not artificial. They are real."[1] He believes that every method possible should be used to catch subscribers and then "wait for the vaccination to take." He believes that the arts in themselves will sweep the audience into total commitment once they have been seduced by the magical powers of DSP.

Of all the changes that have come about since World War II in the way the arts do business, probably none have been as pervasive as those brought about by a quarter-century of Danny Newman's passionate evangelism for the "saintly season subscriber." DSP, combined with the sophisticated techniques of marketing and the flamboyance of old-time press-agentry, reshaped the system by which the performing arts think about and reach out for audiences.

How does the new system of promotion work? How *well* does it work? What are its strengths and weaknesses? Can it be used effectively to meet the new challenges of audience development emerging at the end of the 1980s?

ACT

THE PRESENT

TWO

THE SYSTEM AS IT STANDS

"Mrs. Carter, this is Sally Thompson with the Phoenix Symphony. We're calling as a service to help you reserve the best possible seats to our exciting 40th Anniversary Season."

It was an August evening in 1986, and Sally Thompson, formerly a professional in the advertising business, was selling subscriptions to the Phoenix Symphony's coming season over the telephone as part of the paid staff working in the symphony offices under the direction of Stephen Dunn & Associates, telemarketing consultants based in Los Angeles.

"In addition to our regular Classics, Chamber and Pops series, we have some wonderful new programs and guest artists this season." She pushed through the script quickly to get to the key question. "But tell me, what kind of music do you prefer—classics, chamber music or pops?"

Sally paused and listened to Mrs. Carter's reply.

"Is there a specific *reason* you're not interested?"

As she thanked the woman for her time and prepared to hang up, she made a note next to the Carters' name: "Sounds like long-hair music. Don't like that. If it was country-western, they'd come."

Sally looked over several sheets of names and picked out her next calls. She noted that she should do a callback in a few minutes to a man named Greg to whom she'd mailed a copy of the season-ticket brochure a few days ago. When she first called him, he didn't remember receiving one, although everyone on the lists had been mailed a brochure a few weeks back. She wasn't sure that Greg—a high-school athletic coach who had never attended any kind of symphony concert—was a very "live" candidate. But she always figured that anyone who wanted to talk further must have "some noodle of predisposition" to attend. She decided she had time for one more new call before the callback, so she turned to another group of names.

The lists the ten callers were using had been prepared by Enertex Marketing in New York City through a sophisticated, computerized merge/purge procedure. The Phoenix Symphony had supplied about a half-million names and addresses, of which approximately 44,000 were the symphony's own list, with the rest coming from magazines, other cultural organizations, lists of certain categories of homeowners and other sources. Enertex had reduced the half-million to about 200,000 by first eliminating duplications and then selecting those people who most closely matched the profile of the symphony's previous subscribers through a computerized system Enertex calls TRIM, for Targeted Response Improvement Method.

Sally dialed another name. "Mr. Ross, this is Sally Thompson with the Phoenix Symphony, and we're calling as a service. . . ." There was a click. A hang-up. She made a note on her report sheet. Three or four out of every one hundred calls were hang-ups, she had observed, and about one-third just plain weren't interested.

She reviewed her notes on the callback to Greg, whom she hoped to turn into a subscriber of some kind. In a minute, she had him on the phone. "Now that you've had a chance to look

36

over our brochure, Greg, tell me what kind of music do you think you prefer—classics, chamber music or pops?"

She listened for a moment. "Greg, I'm not sure I know what you mean when you say you're 'faceless' about music. Do you mean you really don't have a preference?"

She sensed that he was shy about admitting his lack of musical experience. She had a feeling she was losing him.

"Did you read about our outdoor pops concerts under the stars? Where you can sit at a table and have food and beverages? It's really fun, Greg, and we have a three-concert subscription series this fall that's just $85 per person."

Greg seemed uncomfortable with the idea of spending $170 on tickets for his wife and himself.

"Well, if you can't go this fall, we have a spring series with Doc Severinsen conducting two of them and Henry Mancini the other. It would be a wonderful treat."

Sally's face broke into a smile.

"That's just great, Greg. I know you'll have a fabulous time. By the way, can you give me the number of the check you'll be mailing in so we can be watching for it?"

Like the Phoenix Symphony, performing arts organizations all over the country have borrowed new techniques from the commercial world to make Danny Newman's system of Dynamic Subscription Promotion (DSP) work more effectively. Mailing lists have been merged/purged by sophisticated computerized systems, professional telemarketers have been employed to make the contacts, and innumerable variations have been played upon the Newman theme of packaging and discounting series of attractions. New kinds of events and new methods of selling have also been introduced.

Although the methods of audience development have changed enormously over 25 years, the Newman *concepts* remain the fundamental cornerstone of promotion for the performing arts. The principle of relying *primarily on season tickets to reach new audiences* and persuade them to make instant, long-term commitments to an institution is etched indelibly in the consciousness of arts managers and trustees. Extensive promotion of single tickets is regarded as inefficient. Selling out to subscribers is still the coveted goal.

Newman himself may deplore what he considers a dilution of his fundamental principles by some of today's managers and marketers. (Asked by one how he defined marketing, Newman shot back: "Going to the store to buy groceries.") And many organizations disavow rigid adherence to Newmanism in their audience-development efforts. But the fact remains that

37

the vast majority of performing arts institutions in America today spend more money on their annual season-ticket campaigns than on any other single aspect of promotion, sales, public relations, outreach or publicity. The $230,000 the Phoenix Symphony budgeted for its 1986-87 subscription campaign was 25 percent more than the allotment for all other audience-development efforts *combined*—everything from single-ticket advertising and publicity to a newsletter and educational programs.

It is small wonder that in the beginning performing arts organizations so wholeheartedly embraced DSP. It enticed new people, in record numbers, to try an organization's offerings for the first time, and it allowed an opportunity for "the vaccination to take." Subscription drives brought in "up-front" revenues for planning, rehearsal and production periods when single-ticket income was not being generated. The guaranteed audience protected institutions from the vagaries of weather, negative reviews and unsuccessful productions. And selling subscription tickets once, at the beginning of the season, was less expensive than selling single tickets for each production or performance.

These economic benefits won DSP the support of the new patrons, concerned as they were for the financial stability of expanding and emerging arts organizations. But season-ticket sales also seemed to offer an important artistic benefit: along with an institution's standard fare, an artistic director could schedule adventurous, controversial, strange or difficult works for which single-ticket sales might be difficult. The subscription audience, so the theory went, would attend everything, since they had bought everything as part of a package. And because they had saved money through substantial discounts, they would "take their punishment in good spirit."

The gospel of DSP as Newman originally preached it called for including all or nearly all of an organization's offerings in *one* subscription package. The customer was asked to buy everything. But as organizations increased the number of productions and performances, broadened the scope of what they were presenting and—to finance their expansion—sought to increase the number of subscribers, the selling became more difficult. Consequently, many organizations began to develop *several different packages* within the subscription system, sometimes differing primarily by size, sometimes by content and sometimes by flexibility of choice. In order to target accurately potential buyers for specific packages—and to keep overall audience attendance growing—more sophisticated techniques of research, direct mail, telemarketing and motivation were applied to the basic Newman concepts.

But these innovations did not fundamentally alter the approach to audience development which Danny Newman has been promoting since 1961. The system in place today is firmly rooted in DSP:

Most performing arts organizations in America focus most of their

38

promotional resources on selling one or more season-ticket packages with sophisicated marketing techniques; this is their primary method of reaching out for new audiences and holding onto the ones they have. The other components of an organization's audience-development strategy are secondary and often unrelated to each other or to the subscription efforts.

To promote a season that begins in the fall, the typical performing arts organization would observe the following schedule. It starts with a subscription-renewal campaign. Sometime after mid-season, anywhere between January and June, a strong effort is made to sign up current season-ticket holders for next season, at as low a cost per dollar of income as possible. Sales are "leveraged" by allowing old subscribers to retain seating priority—*if* their purchase is made before season tickets are offered to *new* subscribers. The renewal campaign usually relies on direct mail, which may be as simple as a billing form or as fancy as a fat packet of colorful promotion materials. Generally the mailing is supported by lobby promotions at performances, and often volunteers are enlisted to telephone forgetful or recalcitrant subscribers and coax them back into the fold.

Once the renewal deadline is past, the organization brings out the big guns and aims them at *new subscribers*. The primary sales tool in the public season ticket drive is *The Brochure*, usually some form of self-mailer with the format and language based on the classic Newman model. The brochure will be sent to everyone on the organization's "in-house" mailing list, and most likely additional lists will be borrowed or purchased from other arts organizations and from commercial sources. These outside lists will get the message to people who have never come anywhere near the events sponsored by the mailing organization, and often the number of brochures mailed to borrowed and purchased lists is *many times greater* than the size of the organization's own list. The Phoenix Symphony, for example, mailed their 1986-87 season brochure to 600,000 homes, of which only 44,000 came from their own list. The goal was to get 7,650 new subscribers beyond the 8,300 they hoped to renew from the previous season.

This concept of huge mailings to people outside the organization's own family is based on Newman's absolute conviction that the right package of benefits coupled with a strong sales pitch can make a subscriber out of almost anyone, *whether or not they have ever attended or even heard of the arts organization involved.*

Newspaper, magazine and broadcast advertising are sometimes used to support direct mail. Special sales teams may be organized to sell subscriptions to businesses or to clubs and social organizations. The famous Danny Newman "coffee parties," thrown by enthusiastically dedicated volunteers to sell tickets to friends and neighbors, are still a mainstay of many a campaign, though the enthusiasm tends to wane as year after year of coffee

39

Newspaper, magazine and broadcast advertising are sometimes used to support direct mail. Special sales teams may be organized to sell subscriptions to businesses or to clubs and social organizations. The famous Danny Newman "coffee parties," thrown by enthusiastically dedicated volunteers to sell tickets to friends and neighbors, are still a mainstay of many a campaign, though the enthusiasm tends to wane as year after year of coffee parties go by. And since the early 1980s, professional telemarketing has been added as a major component in many subscription drives. But whatever the components and whatever the sequence, the subscription campaign is *the big promotional effort of the year*.

Beyond this, old fashioned press-agentry—now known more sedately as publicity or public relations—still plays an important role in the operations of performing arts organizations and is usually considered the most important tool for selling *single tickets* to those performances not sold out to subscribers. It is generally, and validly, held that mounting advertising campaigns for *every* individual concert or show is prohibitively expensive and—if subscriptions can provide attendance at a very high percentage of capacity— unnecessary. The inclination, therefore, is to rely on free publicity for single-ticket sales and to use paid advertising *only* as a service to people already planning to attend or predisposed in that direction *or* to "hype" a concert or production that is in trouble. Sometimes, a special single-ticket advertising campaign may be *planned* for an event that the management anticipates will not be a popular one and will need extra help. (Such an approach can be self-defeating if it attracts new people to an event that does not please them.)

Some organizations do put substantial effort into selling blocks of single tickets to clubs and other social and business groups. Normally, these *group sales* are handled by an individual or a department operating quite independently of the rest of the audience-development and marketing functions. The objective is to fill empty seats and earn income by matching the nature of an event with the interests of a particular group of people and letting the group leadership assist in the sales process. Many organizations with enthusiastic and aggressive group sales people do a substantial amount of business with such programs.

Beyond group sales, however, the promotion of single tickets to regular subscription events is left primarily to publicity, to free listings in newspaper entertainment calendars, and to whatever public-service broadcast time can be promoted. Only occasionally are paid advertisements scheduled, usually in a Sunday newspaper entertainment section.

The exception to this minimal approach to single-ticket sales is with those special events that are *not* included in a subscription package. In recent years, performing arts organizations have been under growing pressure to increase their earned income. The presentation of special events that are

40

more commercial than a company's regular fare is one way to accomplish this. Popular specials include *The Nutcracker* for ballet companies, Charles Dickens' *A Christmas Carol* for theaters, and *The Messiah* or any of a variety of holiday-music concerts for symphony orchestras. The rationale for not including these events in the subscription series is that they appeal to a different audience who will return year after year, whereas regular subscribers will not be interested in seeing such a production every season, if at all.

Specials may include attractions which have the potential to produce strong earned income but do not fit into the "artistic profile" of the basic subscription fare. Initially, symphony orchestras only presented pops concerts as specials, and no more than one or two of these a year; but eventually separate pops series were created. Many symphony people do not see the pops as being related in any way to their main season. The 30-year-old resident conductor of a major symphony put it bluntly in a newspaper interview: "Pops is just something for the symphony to do to reach a different audience entirely and to make money."

Performing arts groups which own or control their own venues may choose to *present* rock groups, pop acts or commercial shows produced by other organizations which they do not consider appropriate or saleable in their own subscription series. And then there is the *star benefit*—Mikhail Baryshnikov, Luciano Pavarotti or Frank Sinatra presented in the biggest hall, arena or stadium available, with or without admittance tied to a subscription purchase.

Generally these kinds of special events are treated separately from the regular offerings and promoted in the more traditional ways of marketing an individual product—with publicity and advertising, and sometimes direct mail. Many managers do not believe that the people who attend these specials represent potential audience for their regular subscription series. Still, whatever names and addresses can be captured at special events likely will be added to the in-house mailing list for next year's season-ticket campaign.

An arts organization's mailing list may be a very sophisticated computerized system with dozens of codes for tracking each individual's history with the organization. Or the list may be kept by volunteers on file cards. In any case, during a season it serves a variety of purposes, largely disconnected and uncoordinated. It is often used for fundraising or membership campaigns. People with specific codes by their names may receive a regular newsletter, often featuring articles on volunteer activities and social functions as well as backstage items and a calendar of events. Invitations to social events and notices of classes and educational activities are fed through the mailing list system. And it is one of the key communication vehicles for selling special attractions. But the major function of the in-house list each season is for mailing *The Brochure* at subscription time.

41

No matter what else an organization does to promote itself to audiences, the annual subscription drive is still the main event. The methods and techniques of the campaign have changed and some new glitz has been added to the act, but the central premise remains the same:

New people, whether familiar with an organization or its arts discipline or not, can be most effectively and efficiently motivated to make an instant, long-term commitment to the organization through a package of multiple events offered at a discount and sold through modern techniques of direct mail and commercial marketing.

That is the premise. That is what most marketers, managers, artistic leaders and trustees believe. But are they right? It seems to have been a valid premise in the past. But how well has it *really* worked? How well has it really served the arts, the artists and the audiences? And how well is it working today?

RESTING ON A PLATEAU

It was well after midnight. Sharon Griggins and Peter Davis had been arguing for several hours over the most realistic method of projecting audience growth for the Arizona Theatre Company (ATC). Both were bleary-eyed from analyzing statistics, but Davis decided to look once more at the attendance data he had collected from 15 well-established resident professional theaters around the country. He dug a long chart of penciled numbers out from under one of the piles teetering on the dining room table and hunched over it under the dim light of the art deco

chandelier; his fingers started punching away at a calculator. Griggins, taking advantage of the pause, went to the kitchen to heat water for more tea and to get a beer for Davis.

Griggins was director of marketing and public relations for the Tucson-based professional theater; Davis, her husband, was working with her as a consultant on a detailed study of the company's future needs for performing and production facilities. They had to make some kind of realistic estimate of expected attendance in the year 2000. It was a difficult assignment.

When Griggins returned from the kitchen, Davis was still working away. She watched over his shoulder for a time but couldn't figure out what he was up to. In regard to future audience growth, she was the optimistic one, which was the way a marketing director should be, she thought. Since making the transition to a fully-professional company in the mid-1970s, ATC had achieved major increases in attendance, doubling the total between the 1976-77 season and the most recent one, 1983-84. Tucson's population had increased by only 30 percent during the same period, so ATC was growing far faster than the city. She knew the company couldn't count on sustaining that rate indefinitely, but on the basis of past history, she felt that ATC could logically project growth in audience *greater* than population growth for some time to come.

Davis was more pessimistic. More than two percent of Tucson's population was already attending one or more ATC performances a year, a fairly high market penetration compared to most resident professional theaters, whose histories, he felt, could provide a reliable vision of ATC's future.

Eventually Davis leaned back and held up a yellow pad for Griggins to see. He pointed to a string of numbers under headings from 1977 to 1983. "Okay, here are the *combined* audience statistics for our 15 regional theaters. This is the average attendance per play over the seven most recent seasons."

Griggins pushed the pad further under the lights so she could read Davis' scrawls better.

"Over those seven seasons the average attendance per play has increased by about 25 percent. But look." He circled the numbers for the first three of the seven years. "Almost all of that growth happened before 1980. Since that time, it's stayed practically the same."

Griggins sat back and sipped her tea and thought about what the numbers meant. "They've really leveled off in growth, haven't they?"

Davis nodded.

44

"I suppose we better face the fact that it will probably happen to us soon, too," Griggins concluded.

Eventually Griggins and Davis arrived at a compromise formula for projecting future audience growth for ATC, a middle ground between the extreme of extending past rates of increase and settling for a fixed percentage of the population. In the process, they accepted the concept that the growth of arts audiences is slowing substantially and is probably approaching stagnation.

Griggins and Davis were not the first arts professionals to note the phenomenon. Managers of all kinds of cultural institutions in all parts of the country have begun to see attendance curves flatten out during the 1980s. Steady growth is continuing at some organizations, while at others the attendance figures bounce up and down so erratically that it would take a magician to detect a pattern. But the information available from an overall perspective suggests a definite, nationwide trend: the arts are reaching a plateau in the development of audiences. The rate of growth in *numbers* of participants has slowed substantially and, in many instances, stopped altogether.

Even more telling, the socio-economic profile of arts audiences is almost exactly the same as it was 20 years ago. The same kinds of people are attending. And the same kinds of people—the vast majority of the population—are staying away.

Because only the sketchiest base of attendance data is available from 15 to 20 years ago, it is difficult to document in detail the apparent leveling off of audience growth. But what Peter Davis spotted in the trend of average attendance per production of 15 theaters over seven seasons seems to be fairly common—strong growth in the 1970s followed by a leveling off in the 1980s. The growth curve for those theaters is shown in Table 1. The other curve on the chart shows the growth in total attendance for symphony orchestras, going back to 1965. The pattern is similar. From a modest growth rate in the late 1960s, attendance increased more rapidly in the 1970s and then began to flatten out by the 1980s.

In Chicago, attendance at seven city-supported museums rose throughout the 1960s and 1970s, but then it began to slow. Since 1975, the totals have remained almost level, as can be seen in Table 2.

In Santa Barbara, California, the growth of arts organizations in the late sixties and seventies was explosive. By 1985, however, a consultant carrying out a cultural inventory and assessment concluded that the "market was saturated," that the available audience had as much cultural activity as it wanted and that the base could probably not be expanded.

Although there are no reliable figures for comparing pre- and post-1960 audiences, even a cursory examination of the available evidence

45

TABLE 1

TRENDS IN SYMPHONY ATTENDANCE AND THEATER REACH

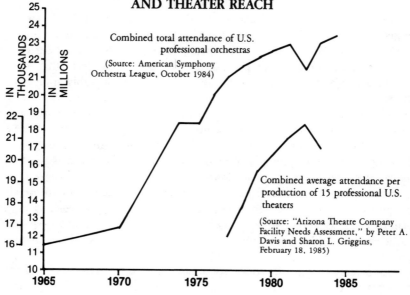

Combined total attendance of U.S. professional orchestras

(Source: American Symphony Orchestra League, October 1984)

Combined average attendance per production of 15 professional U.S. theaters

(Source: "Arizona Theatre Company Facility Needs Assessment," by Peter A. Davis and Sharon L. Griggins, February 18, 1985)

strongly suggests that total annual arts attendance in the entire United States has increased at least tenfold in the last quarter-century. Some of that growth is due simply to increase in population. But the most influential factor has been the wider availability of the arts throughout the country. And this, as shall be seen, is the key to both the phenomenal growth and the recent, in some cases abrupt, leveling off of arts attendance.

When a community has no cultural events, there is no attendance. When art becomes available, a certain segment of the population will attend almost automatically. During the 1960s and 1970s new arts organizations —professional and amateur—were springing up at a breathtaking rate. A wide breadth of arts activity became available in parts of the country where little or nothing had existed before, and towns and cities that already had a few cultural institutions found themselves with a new variety of choices. Total attendance in the nation grew accordingly. When the arts came to town, the people—at least a certain percentage of them—came to the arts.

Studies begun in 1973 by the National Research Center for the Arts, Inc. (an affiliate of the opinion research firm of Louis Harris and Associates) showed that participation in the arts by adult Americans, both as audience members and as amateur or avocational artists, was on the rise. While the actual percentages of public participation in various kinds of arts activities

46

compiled nationally by the center are viewed skeptically by many arts professionals because they exceed so substantially any documentable statistics at the local level, no one challenges the evidence of *increases* in participation shown by each succeeding study. It is an undisputed fact that for 25 years, as new organizations opened their doors and as existing institutions increased their offerings, record numbers of Americans passed through those doors and paid to be part of the excitement.

However, in the eighties, as the decentralization and proliferation of the arts has begun to slow, so has the growth in attendance. Even the normally optimistic studies conducted by the National Research Center for the Arts have begun to reflect this trend.

To understand the reasons for this slowdown, it is helpful to consider some nontraditional ways of measuring and analyzing audiences. Every community contains a number of different *types* of people, in terms of interest and potential interest in participating in arts activities. The Stanford Research Institute's VALS concept divides people into nine groups by values and lifestyles, and cultural interest is one of the elements taken into account. But it is also possible to categorize a population using *only* the

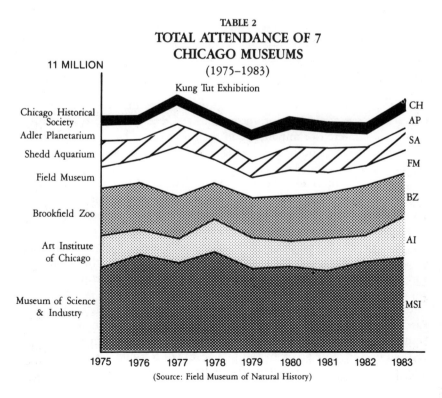

TABLE 2
TOTAL ATTENDANCE OF 7 CHICAGO MUSEUMS
(1975–1983)

(Source: Field Museum of Natural History)

Resting on a Plateau

cultural element, which is what Bradley Morison and Kay Fliehr did in their early work at the Guthrie Theater. They came up with four types of people, and they gave them simple, unacademic names: the Yeses, the Maybes, the Noes and the Ineligibles. Everybody in any community fits into one of those categories. Here is how they are defined.

The *Ineligibles* are people who are too old, too young, or who are incapacitated or incarcerated and cannot go to a performance hall or museum. Arts organizations may take programs *to* the Ineligibles, but these people are not potential attenders of traditional events held in traditional places.

The *Yeses* are people who, because of something in their background or education, have come to accept the arts as an important part of their lives. They are predisposed toward active participation, and as a matter of course, they attend a variety of cultural events. The Yeses are the backbone of the regular audience and patrons.

The *Maybes* are those people who, to one degree or another, are uncertain about whether or not the arts are or can be important to them. Some Maybes are intimidated by what they perceive as the formality of performance halls or museums and the crowds who gather there. They may be uncertain whether they "know enough" to be able to appreciate the arts. But though they are apprehensive about Culture with a capital "C," once in a while Maybes will venture out to try an event that appears accessible and unintimidating. If the experience is not too painful, they may try something else. Between the Yeses and the Noes, there would appear to be several "sub-categories" of Maybes.

Finally, the *Noes*, because of something *missing* in their background or education, have consciously or unconsciously *eliminated* the arts as being of any possible interest or importance in their lives. They have "turned off" to arts activities and do not read what is written about them or hear what is said. They have drawn a kind of "cultural curtain."

Initially, Morison and Fliehr estimated that, on the average, three to five percent of the population were Yeses, 12 to 15 percent Maybes, 30 percent Ineligibles and 50 to 55 percent Noes. While the proportion of the population in each category may vary substantially from one community to the next, depending on the demographic profile of the population, research carried on around the country by the consulting firm that Morison and Fliehr later formed generally confirmed those proportions. Rarely did any community have more than 20 percent of its population participating in the arts—the total of Yeses and Maybes combined. A study on Public Participation in the Arts carried out in 1982 by the Survey Center at the University of Maryland suggested that 40 percent of *adult* Americans participate in one or more arts activities in a year, which would amount to about 29 percent of the *total* population—the base used by Morison and Fliehr.

Because determining how many people participate in the arts is heavily dependent on how "the arts" are defined, it is difficult to relate one analysis to another or to determine whether the actual proportion of cultural participants in the population has changed over 20 years. Certainly because of the "politicalization" of the arts, a wider range of activities is now being defined as art than was the case in 1960. But there is little evidence to suggest that, once a community reaches "cultural maturity," the proportion of combined Yeses and Maybes will exceed 20 to 25 percent—for every conceivable kind of cultural activity.

This combined total of all the Yeses and Maybes constitutes the total audience, or *reach*, of all the arts in a community. The reach of a specific arts organization is made up of its own Yeses and Maybes.

The related concepts of *reach* and *frequency* are helpful in making accurate measurements of audience size and trends. They are particularly important to an understanding of the growth plateau at which the arts have *arrived*. Reach and frequency provide a much more realistic picture than attendance figures of how well a community or institution is doing in touching the lives of the people it is trying to serve.

Reach for a community is the total number of *different* people who attend one or more arts activities or events of any kind in a given year. For a specific arts organization, it is the total number of different people who attend one or more of the organization's programs, performances, exhibitions or other activities in a 12-month period.

Dividing the reach by the population of the community's market area produces a *reach percentage*—the proportion of the market whose lives are being touched. Reach percentage allows comparisons between communities and between arts organizations in the same or in different areas.

Frequency is the average number of times during a specific year that people included in the reach *participate* in the arts activities of the community or the events of an arts organization.

The relationship between reach, frequency and attendance is simple:

Reach × Frequency = Total Annual Attendance

(A detailed explanation of how to determine reach and frequency and how to use them in analyzing audience size and trends is contained in the appendix.)

Reach percentages for larger, well-established arts organizations generally run between one and three percent of the population, although few institutions have actually done the research necessary to determine the figure accurately. One reason for the reluctance is that reach percentages seem relatively small. Boasting to a funder that your attendance topped 330,000 last year is more impressive than saying that you reached two percent of the population.

49

Where reach percentage has been determined accurately, the figure rarely exceeds three percent. One to two percent is the norm for larger institutions; for smaller groups with adventurous programming, the figure is almost always less then one percent.

During their study for ATC, Griggins and Davis computed the reach percentage for the same seasons of 34 resident professional theaters. The companies represented a wide range of size, age and artistic policies in markets ranging from 200,000 to 4.6 million. Though because of methodology the Griggins/Davis figures may be slightly low, the average reach percentage for the 34 theaters was 1.2 percent. The extremes ranged from 0.27 percent for a small theater producing primarily new plays in a market of two million, to 2.3 percent for a well-established theater presenting classical and contemporary work in a market of almost one million. The Alaska Repertory Theatre in Anchorage went off the top of the chart with a figure of 7.3 percent, attributable primarily to its isolated location. Reach percentages of that size occur only rarely and in idiosyncratic situations.

EXAMPLES OF REACH PERCENTAGES

Here are a few examples of reach percentages for other kinds of organizations.

For three seasons the Tucson Symphony Orchestra hovered around 1.2 percent reach, then rose to 1.4 percent in 1984–85, and to about 1.6 percent in 1985–86.

For several successive years, the Saint Paul Chamber Orchestra appears to have had about 20,000 different people attending one or more concerts. That is about one percent of the SMSA population and around 0.6 percent of the people within a 100-mile radius, the area generally accepted as the primary arts market for Minneapolis and Saint Paul.

Even the Philadelphia Orchestra performs for less than one percent of its metropolitan area population, in part because a majority of its concerts are nearly sold out to subscribers, so there is little room to extend reach through single-ticket sales.

A very high-quality and successful performing arts series presented by William Jewell College in Kansas City had a reach percentage of only about 0.3 percent in a recent season, despite the fact that it had empty seats available for single-ticket sales.

50

In the museum field, some of the largest institutions achieve reach percentages substantially higher than comparable performing arts organizations. In Chicago, the Art Institute reached about 570,000 people from the metropolitan area in a recent year, for a reach percentage of about seven percent. But smaller museums generally fall more in the range of performing arts organizations. In the same year that the Art Institute of Chicago reached seven percent of the SMSA population, the city's Museum of Contemporary Art apparently reached no more than one percent.

Evidence indicates that most arts organizations in the United States are currently reaching three percent or less of their population, and that attendance is beginning to hold at those levels.

The most telling example of the plateau phenomenon comes from the Guthrie Theater in Minneapolis, an institution that emerged full-blown in 1963. Rather than growing from an acorn, the Guthrie was "planted as a full-grown oak tree" and was enormously successful in attracting audiences from the beginning.

Although there have been peaks and valleys season-by-season, annual attendance showed fairly consistent growth through the first ten years of the theater's existence, and then began to level off. *But the percentage of the population being reached seems to have remained almost exactly the same throughout at least the first eighteen seasons of the Guthrie's life.* Here are the facts:

THE GUTHRIE THEATER'S REACH PERCENTAGE

	1963	1973	1981
Number of plays	4	7	9
Total attendance	183,931	211,404	328,315
Population in 100 miles	2.75 mil	3.21 mil	3.43 mil
Reach Percentage	2.10%	2.13%	2.08%

The theater was still reaching the same proportion of its market in 1981 as it had in the beginning. Population had grown, and attendance grew even faster. But the number of plays also increased. The same percentage of the population was simply attending with higher frequency.

The evidence suggests that, apart from its "instant maturity," the Guthrie Theater and its unchanging reach percentage are not unique, that as other organizations mature and stabilize, they, too, experience, or will experience, a leveling off of reach percentage—even when there are empty

51

seats still to be sold. Significant light is shed on the reason for this phenomenon by another statistical measure: demographics.

Though the arts have grown considerably in attendance and a little in reach over two decades, they have not succeeded in moving far beyond the basic type of person who has always attended and supported them. Demographically, arts audiences are almost exactly the same as they have always been: far above the national average in education, income and proportion of professional and managerial occupations represented. The potential *size* of the audience is therefore limited by the number of these kinds of people in the population.

As an arts organization pushes toward the edges of that demographic base, growth slows and finally ceases. It runs out of predisposed customers. It begins to compete with other institutions for the same, limited market segment.

Studies of their own audiences by a number of individual arts organizations have confirmed the apparent inevitability of this syndrome in various markets. And two general studies compare tellingly with the research done by William J. Baumol and William G. Bowen on the state of the arts in the nation as a whole at the very beginning of the cultural revolution.

In their book *Performing Arts: The Economic Dilemma* the Princeton professors, looking back from their early-sixties vantage point, observed that: "Attempts to reach a wider and more representative audience, to interest the less educated or the less affluent, have so far had limited success."[1] Eleven years later, a research team at the Center for Study of Public Policy said nearly the same thing. And several years after that, when researcher David Cwi compared new statistics with Baumol and Bowen, his findings were almost identical.

The Center for Study of Public Policy project, commissioned by the National Endowment for the Arts (NEA), was a critical review of 270 different audience studies that had been carried out by performing arts institutions and museums, primarily in the 15 years after the Baumol and Bowen study was made. The Center team concluded that: "In sum, the studies show that the culture-consuming public is more educated, has higher incomes, and has higher status jobs than the general public. We could find no evidence that audiences were becoming more democratic. None of the variables showed any significant change in time over the last fifteen years for the performing arts, the only studies for which we had sufficient data."

At about the same time that the above report was issued, David Cwi was beginning some extensive research with arts audiences. In 1980, in a paper published by the Cultural Policy Institute, he compared some of his findings with those of Baumol and Bowen to determine whether the base of the performing arts audience had broadened. Cwi concluded that for the most part it had not.

What changes there were had occurred primarily because of changes in population characteristics over two decades. For example, there had been increases in the proportion of the population with college degrees and those employed in white-collar professional and technical categories. Even so, Cwi found his audience statistics from 1980 to be extremely similar to the Baumol and Bowen figures from the beginning of the 1960s. Seventy percent of his sample were employed as professionals. Baumol and Bowen's figure was 69 percent. Cwi's data on the incomes of arts audiences differed from Baumol and Bowen's by no more than four percent in any one category. The percentage of people in the audience with college degrees or more education was an identical 73 percent in Cwi's sample and in Baumol and Bowen's.

Overall, Cwi concluded that the growth in arts audiences over 15 to 20 years had *not* been due to an expansion of reach to encompass a broader cross-section of the public. It had occurred because the population group that has *always* been the audience for the arts had increased a bit in size. In summary he writes: "The historic sociological base [of arts audiences] has grown and now encompasses a larger share of the population. This base has at best been pushed at the edges."

If the arts cannot reach beyond a certain *type* of person in their search for audience, it should not be surprising if growth slows and eventually stops. With DSP, commercial marketing and press-agentry, the arts have been able to reach the Yeses and some of the Maybes, but apparently they can go no further.

Is it possible that the very system the arts have been using to develop audiences is a *limiting factor in itself*, making it difficult if not impossible to rise above the plateau and move ahead toward the elusive goal of cultural democracy? Are there weaknesses and dangers in the DSP-based system that are not immediately evident?

Is it possible that this system—which arts organizations have been using and refining and relying upon since the sixties—may, in the eighties, be discouraging the Maybes from participating fully in the arts?

THE RELUCTANT MAYBES

A drizzly, penetrating April chill enveloped Ron Bowlin as he locked his car and hunkered down in his parka for the long walk to the music building on the University of Nebraska campus in Lincoln. It was very early in the morning, an uncivilized time to be getting to work, he thought; but it would be a busy day, and he wanted some time before crisis took over to look at the box office statement from the performance at Kimball Recital Hall the night before.

It had been a wonderful concert by the Romeros, an internationally-known classical guitar quartet, but Bowlin had been disturbed by the relatively small crowd. The attraction was one of a four-event series which was part of the performance program he had been running at the University since he graduated in 1972. Nearly all of the 850 seats in Kimball Hall had been sold to series subscribers; yet, to Bowlin's practiced eye, the auditorium had looked only about half full, despite pleasant weather.

He found the box office statement from the Romeros concert taped to the door of his office. He pushed aside the piles of artists' promotion materials on his desk and started down the column of figures. He was right. Nearly half of his subscribers had been "no-shows" the night before. He was particularly troubled because something similar had happened with another event in the series earlier in the year. He rummaged around looking for the file on the February concert by Canadian soprano Maureen Forrester, a truly distinguished and usually popular international star.

Bowlin had put together what he thought was an interesting and diverse series: the Romeros, Forrester, England's Young Vic theater company in an exuberant production of *The Taming of the Shrew*, and a dance program called *Stars of the American Ballet*. On top of that, he was presenting six other attractions: in another series, three musical events with a Czechoslovakian theme, plus three specials to be sold on a single-ticket basis— the Nikolais Dance Theater, Pennsylvania Ballet and Saint Louis Symphony.

He found the Forrester file and pulled out the box office statement. It was the same thing. Nearly half of the subscribers had failed to use their tickets. Not the same people, he assumed, but another sizable number who didn't mind wasting tickets if they didn't want to see the event. He thought about it as he fixed himself coffee. He began to wonder if his four-event series had *too* great a variety of attractions. Most of the subscribers had turned out for the Shakespeare and the ballet, but almost half had stayed away from the soprano and the guitar quartet, despite the fact that they were outstanding talents. Maybe he was going too far; maybe it was pointless to try to coerce people into attending a wide range of concerts, some of which they weren't interested in, by selling them discounted packages.

He thought more about it as he hunted around his desk for a package of "plastic" cream for his coffee. Suddenly he stopped short as an idea crossed his mind: If there are people who will actually *buy* a four-event subscription and *waste* tickets because

they aren't interested in certain events, think how many more there might be who *won't* buy a subscription *at all* because there is something they don't want to see and they aren't willing to throw their money away. Perhaps rather than enticing people to sample things they weren't sure of, he was actually *limiting* his audience by insisting that they buy such a widely varied series.

He reached for the phone and called a friend with whom he talked about such things regularly. "Jonathan, I've decided to give up coercion. It doesn't work, and it limits my potential to reach people." He explained his sequence of thoughts further.

"I want people in the seats, not just money in the till. So I've decided to give up the old idea of a fixed series with a wide variety of events on it and give people a discount if they buy tickets to any *four or more* of our ten attractions. A kind of 'pick your own' series. What do you think?"

In analyzing what was happening with his Kimball Recital Hall series at the University of Nebraska-Lincoln, Ron Bowlin put his finger precisely on one of the basic reasons why traditional subscriptions can keep audiences from growing. He was nearly selling out his four-concert series to subscribers; yet half of them were not attending some of the events, primarily because they didn't care for that particular type of offering. They were unwilling to "take their punishment in good spirit," even if it meant wasting a ticket or two.

To be sure, there *was* a base of audience for Bowlin's series that did have a sense of adventure and whose taste was broad enough to encompass Shakespeare, classical guitars, a soprano and ballet. But beyond that relatively small group, others refused to be coerced. They were reluctant to try a wide variety of events, some of which were unfamiliar and strange to them. They were being asked to make too big a commitment too quickly, before they were ready. The new "pick your own" series would allow his audience to become familiar with the series in a way, and at a pace, that was comfortable for them.

As the series has been refined and developed further, Bowlin has begun to encourage his subscribers to try offerings that may be new to them as a way to help them test their sense of adventure at their own pace. As a result, the UNL/Kimball Hall Performance Series has grown consistently. It is one of the most varied and eclectic menus of events of any college/university concert series in the country. And it is thriving.

Bowlin was certainly not the first entrepreneur or manager to create a flexible series or divide a season into smaller packages for subscribers. But when he did it, he was seeing the problem from a slightly different per-

57

spective than many had before or since. It was not just a matter of trying to create a more saleable product. He recognized that if he continued to cling to the traditional subscription concept, he would actually be limiting his audience to people with an already developed sense of artistic adventure *or* to people of substantial financial means who didn't mind wasting a ticket or two. The fundamental season-ticket concept attracts, almost exclusively, the adventurous and the affluent. Beyond those small groups, there is a reluctance on the part of the public to participate in the arts within the system the arts have been insisting upon.

Throughout the country arts organizations of all kinds are experiencing a reluctance from new audiences to take on large commitments through subscription packages and to try adventurous work in that context. As the available supply of Yeses had become depleted, managers have had to dig more deeply into the Maybes to broaden their subscription bases. The Maybes have been harder to sell, and when they *have* bought season tickets, the "vaccination" has not taken as readily or as completely as it always did with the Yeses. David Hawkanson, managing director of the Hartford (Connecticut) Stage Company, says that it is getting more difficult to bring new people into the theater with season tickets and that, generally, fewer new subscribers are being added each year. "In addition, the drop-offs [of subscribers] at the end of each season are getting higher. We [arts managers and artistic directors] are experiencing shock waves over what audiences are willing to accept. They are less loyal than they were before. Expectations are not being met."

These problems are especially evident when the long-term results of telemarketing are examined. Many managers believe that telemarketing has become the most effective way of selling subscriptions to new people, and a large number of arts organizations have had great initial success employing the services of professional telemarketing firms.

But some administrators, including Hawkanson, report that there is a substantially higher drop-off rate at renewal time among new subscribers solicited by telemarketing than among subscribers sold by other means. One professional firm that manages telemarketing campaigns for arts organizations surveyed a number of institutions that have used the technique. They found that most show renewal rates of less than 50 percent for subscribers sold by telemarketing, as compared with a renewal rate of 70 percent or higher for other subscribers. A major symphony orchestra reported an overall renewal rate of about 80 percent; but among new subscribers sold by telemarketing, renewal was only 35 to 40 percent. Another client—a professional theater company—showed an overall renewal rate of just under 70 percent, but less than half of their telemarketed subscribers renew.

Apparently the aggressive techniques of telemarketing are persuading people to buy things they are not prepared to accept. And after one season

58

they are walking away, many turned off forever by the experience.

Those calls to instant commitment that lured the Yeses are not working as well with the Maybes. They are less ready to make a commitment to attending a number of events spread over a long period of time. With season tickets running as high as $200 to $300 or more for two people, they are less willing to spend the money—particularly when they are uncertain about the product. The wide variety of events found in many subscription packages, part of the appeal for the Yeses, is often intimidating to the Maybes. Also intimidating for many of them is the "aristocracy of good taste" that DSP-inspired brochures promote. People interested in the prestige and social benefits of attendance find this attractive, but those Maybes who are not interested in belonging to an exclusive circle may be frightened away.

The problem of the reluctant Maybes is one that some arts managers and board members are beginning to sense. Among many, there is an uneasy feeling that far too much emphasis is still being placed on subscription sales. But the financial stability that has been achieved through subscriptions and through the sale of single tickets to more popular specials has made managers and boards timid about trying anything too far afield. Says Frederic B. Vogel, executive director of the Foundation for the Extension and Development of the American Professional Theatre (FEDAPT), "We seem to have forgotten that subscriptions are not an end, but a means to an end. The tendency [for arts managers] today is to think that once they have established some stability, they shouldn't rock the boat."

The arts are trying to force a new breed of Maybe audience into a ticket selling system that primarily benefits the organization rather than the potential customer. And the new customers aren't buying.

As the arts reach more deeply into the Maybes and some of the Noes for audience, they must take more time, have more patience and be more caring. Arts organizations must accept the responsibility of helping these people to overcome their intimidation and uncertainties.

We do not believe that arts organizations should abandon the use of subscription, but that they should be more discriminating about its application. They must integrate it into the audience-development system in a different way in order to minimize its disadvantages. Managers and boards must reassess the goal of selling out to subscribers in favor of the much broader and more significant objective of developing stronger relationships between people and art, between audiences and artists.

The difficulty of reaching into the Maybes and Noes for new audiences and moving off the plateau of attendance growth is not attributable solely to reliance on a DSP-based system of audience development. The problem is compounded by a diffusion of purpose and a confusion of principles which seems to have occurred in part through the widespread infusion of commercial marketing philosophies into the world of the arts. In addition

to recognizing the weaknesses and limitations of DSP, arts organizations must also be aware of the dangers and limitations of the indiscriminate application of marketing concepts to audience development.

HAVE THE BEACHCOMBERS WANDERED TOO FAR FROM THE SEA?

The speaker felt inspired that September day in 1974. As he listened to the host introduce him at a meeting of the Business Committee for the Arts, he was certain that the images he intended to use in his talk on "Business, the Arts and Boards of Directors" would make his points well.

"And now it gives me great pleasure to introduce our speaker," the host was concluding, "Mr. Paul Lepercq, chairman of the New York City securities trading firm, Lepercq de Neuflize, and chairman of the board of directors of the Brooklyn Academy of Music."

Lepercq made his way to the rostrum, clutching the notes he had made during the shuttle flight to Washington, D.C. "Ladies and gentlemen," he began, "let's talk about boards. There are three points I am going to cover. One is: how is it that boards are ineffective and powerless?"

He moved ahead rapidly, making his points with a dynamic energy and flamboyance befitting a Frenchman, speaking with a bit of an accent even though he had come to the United States nearly 30 years before. Tall, slim, blond and debonnaire, he quickly swept his audience away with his imagery and his perceptive observations.

"Why are boards ineffective? And the image which comes to me is that, very simply, when we are talking about business, when we are talking about the arts, we are talking about two different worlds, where the rules of the game are very different. And it is as if you would put on a field two teams—one of football players and one of soccer players—and you would tell them to play. Let me tell you, nothing happens! They would be paralyzed, and they would not know what is expected from them."

Lepercq moved on to talk about a board's role in administering an arts organization. In his two years as chairman of the Brooklyn Academy of Music (BAM) board, Lepercq's primary mission had been to help educate BAM's artistic director, Harvey Lichtenstein, and his staff in the ways of efficient management.

"An arts organization which does not raise money is dead," Lepercq continued. "Every director must be involved in the process and there again, the image I had in June, which I found very helpful for myself. . . ." He searched a bit for words. "It is very much like in the cavalry: you have a cavalry man who is a cook, one who is a medical man, one who is a sharpshooter, but everybody rides a horse. And with boards of directors, everybody should ride a horse: should raise money."

Lichtenstein had met Lepercq several years after the artistic director first took over at BAM in 1967. Lepercq had recommended the Maurice Bejart dance company for BAM and promised to help raise funds to bring them to this country if Lichtenstein liked them. He did. Lepercq raised the money and had been riding a horse for BAM ever since.

He finished the three points of his speech and began his windup.

"I am going to give you an image. . . . the image has been very helpful to me in nurturing my enthusiasm for what I do between arts and business, for providing a focus for it. . . . I was talking about the two different worlds of business and of the

arts. I could say—and I like the image—that business is the earth, the solid earth, the land; and the art is the seas.

"When there are two worlds meeting, and when you operate at the fringe of it, what is extraordinary is that you, in fact, operate in a third world. There is something new there; there is a third something.

"Between the land and the seas you have the shoreline, which is an extraordinary, exciting, changing world. And I remember twenty years ago I read the book of Rachel Carson, *The Edge of the Sea*, and it has really changed the way I look at the beach, the way I look at the shore, and what is meaningful to me in terms of what I am doing today between my business and the Brooklyn Academy of Music."

He paused and smiled a charming and disarming smile.

"Also, I like the idea that I am making my friends into beachcombers; I am making our distinguished chairman into a beachcomber; I am making these two distinguished professors into beachcombers; I am making all of you into beachcombers."

Paul Lepercq's image of those who work between the arts and business as beachcombers is a poetic and exhilarating one for administrators, trustees, and patrons. But it is also useful in contemplating the relationship that should exist between commerce and culture. On the beach, nature achieves a perfect balance between two quite different environments—each giving, each taking, each accommodating the other in Paul Lepercq's third world.

It is that kind of ideal balance that the beachcombers should be trying to achieve between business and the arts—between the solid, efficient pragmatism of commerce and the restless, visionary quests of artists. They must keep searching along the shoreline for the perfect middle ground that will allow the arts to draw upon the rich resources of business acumen without allowing differences in values to distort the primary goals, the definitive purpose of art.

Achieving that delicate balance is particularly crucial in the application of commercial marketing principles to the development of audiences, for it is in marketing that differences in values are most profound yet often most difficult to perceive. The enthusiasm in the 1980s among arts trustees and administrators for marketing techniques appears to be leading to an undiscriminating application of marketing principles, endangering the very objectives of audience development.

It appears that the beachcombers may have wandered too far from the sea and lost sight of its majesty, its mystery and its magic.

We are not suggesting that cultural enterprises abandon the use of

63

appropriate marketing techniques, but only that the significant differences between marketing commercial products and marketing the arts be recognized and understood so that the arts can avoid going further astray. At the heart of this is a recognition of the fundamental difference between goals and methods—between the ends and the means used to accomplish them.

In the commercial world, the goal of marketing is to produce a profit— the accumulation of money. In a society based on belief in private enterprise and capitalism, this is a totally acceptable and, for most, an admirable objective.

To reach this goal, practitioners of marketing *manipulate people and products*. While some may find "manipulate" a distasteful term, one dictionary definition of the word is to "manage or influence with artful skill," an unarguably accurate description of the way in which commercial enterprise deals with its products and with its current and potential consumers.

In the arts, the objective and the means of achieving it are quite different. In fact, they are exactly reversed. *The goal is to build a long-term relationship between people and the product—art.*

The purpose of an arts organization is to help make possible the special magic that can happen between artist and audience. The objective of audience development is to create *a love affair* between people and art that will have a lifelong impact on the minds and spirits of those who partake.

To achieve that objective, the trustees and managers of arts organizations *manipulate money*. They manage and influence with artful skill the funders and the funds as the *means* of accomplishing their ends. The desired return on the money manipulated is *not* more money. It is enrichment of the human spirit.

This difference in ends and means between commercial marketing and the development of arts audiences is a profound one. If it is not understood and acknowledged so that sensitive, discriminating judgment can be used in applying commercial marketing philosophies to cultural institutions, then the very essence of art is threatened.

For example, precious staff time and energy can be drained away from an institution's pursuit of its primary purpose by the seemingly constant focus of trustees and managers on increasing the percentage of income earned from ticket sales, admissions, gift shops, food and liquor sales and other, often unrelated enterprises. Fiscal responsibility is an asset to be coveted in an arts organization, but responsibility to art, artists and audiences should be of equal importance. The pressure to be practical in business terms often obscures the possibility that pursuing artistic goals and true audience development objectives with integrity and fierce dedication may require a *lower* percentage of earned income and *more* contributed funding.

Another, subtle danger in the application of commercial pragmatism to the arts is that often corporations (and sometimes foundations and

64

government agencies) interpret being practical in terms of whether or not the programs they support have a tangible payoff for their own goals and objectives.

While a strong case can be made that a vibrant cultural life makes a community a more attractive place to work and helps industry attract better employees, it seems unrealistic to expect business to make a major commitment to the arts for those reasons alone. The accepted position is that an arts organization needs to demonstrate that support of its work generally, or of a specific production or program, will provide tangible public relations or sales benefits to a given business. The strategy is known as appealing to a corporation's enlightened self-interest. The real danger, of course, is that, in pursuit of funding, arts organizations may begin to create programs to appeal to corporations or to suit the needs of foundations and government agencies—with only passing concern for whether those programs are artistically valid or relate to the institution's primary purpose. Said one knowledgable arts executive, "When my colleagues discuss programming for their organizations these days, I hear them talking more and more about what kinds of things are being funded this year rather than what kinds of programs are needed."

PR LEADER QUESTIONS "ENLIGHTENED SELF-INTEREST"

One of the most convincing testimonies to the danger of corporate patrons expecting tangible payoffs from sponsorship of the arts comes from a man whose firm has been one of the leaders in encouraging business support of cultural activity, David Finn of the public relations firm of Ruder Finn & Rotman. In a speech delivered to a statewide conference of arts leaders in Missouri, he said: "It [enlightened self-interest] is a popular phrase. But I have a lot of trouble with it. It's supposed to mean that an enlightened management which appreciates the importance of the arts in our lives believes that its customers, its employees, its stockholders, the leaders of the communities in which it operates, will appreciate support of the arts and that this will redound in some way to the company's benefit.

"I find the concept of enlightened self-interest too slick, too self-congratulatory, too dollar-oriented, too superficial. The arts deserve to be taken more seriously than a strategy to win plaudits from a grateful public. . . . I feel that patronizing the arts for reasons of enlightened self-interest

65

tends to trivialize what is or should be the heart of our civilization.

"What concerns me even more about this concept is that self-interest is measured in business values rather than cultural values. Sponsoring the arts can 'pay off'—so the theory goes—in bottom-line results. This is closer to the appetites for power and prestige among powerful rulers of the past, who as we know were not very enlightened, than to the glory the Medicis dreamed of and ultimately achieved."

In the commercial world, consumer research is used to find out what people like and dislike about a certain product so that the *product can be changed* to make it more appealing. It is the job of those in marketing to make suggestions about altering the product so that it will sell better. When producing a profit is the end, changing the product is an acceptable and desirable means, and it is the responsibility of marketers to recommend ways to do it.

When the goal is creating a love affair between people and a certain artist's vision of art, then changing the product does not help to accomplish that end; it betrays it.

It is totally inappropriate for those who govern, manage or market the arts to suggest that the product be changed to make it sell better. In theory, they have accepted the vision of the artistic leadership and their responsibility is to support that vision and to communicate clearly and effectively its values, meaning and benefits to those who might find enjoyment and enrichment in participating as audience.

If that is done and no one is interested, then eventually the maintenance of the organization will no longer be justified. Or, as an alternative to institutional euthanasia, a board of trustees may choose to select artistic leadership whose tastes and values are closer to those of a larger public. In that case, however, it would appear that *institutional survival* rather than artistic purpose is what is being pursued.

While most beachcombers would probably defend the inviolability of artistic vision in principle, there is evidence that as financial pressures grow, commercial marketing's concept of product revamping as a legitimate method of stimulating sales is being tolerated, if not accepted, with increasing frequency.

This brings increasingly difficult and conflicting tensions to the role of the artistic leader. To induce the new breed of Maybe audience to buy season tickets, there is pressure to include more popular works in the packages. If the artistic leadership yields to this pressure and at the same time insists on retaining or expanding the more adventurous fare encompassed

66

by his or her initial vision, then the packages become "mixed bags" that ultimately satisfy neither the Yeses nor the Maybes but instead confuse everyone about what the institution stands for.

If an organization is to remain true to the artistic director's vision and the institution's original mission, it must eventually accept the fact that most likely it will not be able to accomplish the ultimate objective of DSP: selling out to subscribers. Gary Gisselman, artistic director of the Arizona Theatre Company, believes that subscriptions are a valid audience building tool up until a performing arts organization is about 50 percent subscribed. "But if you want to increase the number of seats you sell to subscribers up to 80 percent or more," he warns, "then you have to start pushing your programming toward the more popular end of the spectrum."

A SYMPHONY ORCHESTRA "REDEFINES ITS BUSINESS"

A major U.S. symphony recently appointed a Marketing Task Force to study audience and potential-audience attitudes toward the orchestra and its programming and to make recommendations for specific action that could help increase ticket sales. The task force made 23 suggestions. The first was stated under the heading "Redefine the Symphony's Business." It said:

"The (NAME OF ORCHESTRA) should redefine its product so as to guide all those who help create what is offered to the public. For example, the current Long-Range Plan says: 'The product of the (NAME OF ORCHESTRA) is its musical programs, its artistic standards, and its service to the community.'

"An alternative description:

"The (NAME OF ORCHESTRA) is in the entertainment business. The product of the (NAME OF ORCHESTRA) is the satisfaction it brings to its present and future audiences. While the musical programs and artistic standards are the internal measure of success, equally as important to the long-range viability of the Orchestra is the extent to which benefits are perceived by prospective ticket buyers."

A subsequent recommendation, under the heading "Tailoring Music to the Audience," suggests that the orchestra should "continue to select compositions for future programs that are lively, rhythmic or melodic, interesting to hear and, if possible, stirring and exciting. Not all pieces

67

need fit this pattern but the overwhelming majority
should."

The orchestra is currently implementing the recommen-
dations of the Marketing Task Force. In the world of com-
mercial marketing, such action is not simply justifiable, it
is imperative. In the world of the arts, it is, at best, of ques-
tionable propriety.

There are other, crucial differences between marketing commercial
products and marketing the arts. One is the way the process is viewed by
the "product."

Commercial products don't care what is said or written about them in
advertising and promotion, and corporate executives and boards of directors
rarely care either, as long as the product sells and produces a profit. Tooth-
paste, toilet paper, tortilla chips, tennis shoes and television sets are not
known to have delicate egos.

It is a different story in the arts. Painters, poets, composers, conduc-
tors, directors, designers, actors, dancers and singers *do* care how they are
sold. And while it is not necessary or even possible to cater to every egocen-
tric whim of every artist, it is imperative that those who market the arts be
sensitive to the feelings of those who create and, in the case of performers,
embody the art. Much of the methodology and vocabulary used by the
writers of product ads and commercials is simply inappropriate in the world
of art and artists.

In commerce, the manufacturer does not particularly care why people
buy a product, only that they do buy and keep on buying. What prompts
a purchase is largely immaterial, except insofar as understanding consumer
motivation may guide a company in altering the product or the advertising
to increase sales.

In the arts, it is *inherent in the end goal itself* that the audience make
its purchase and participate *for the right reasons*. Everyone who attends a
performance should do so because of the enjoyment or the stimulus or the
challenge being offered by the arts. If status and social prestige are the pri-
mary reasons for attending, then the primary goal of the artists and the arts
organization is not being achieved—even if the box office report seems
cause for celebration.

Realistically, along with those who come for enrichment of the spirit, it
is probably necessary for most arts organizations to accept others into the
fold who may be seeking more superficial rewards. When one impassioned
artistic director stated categorically at a conference that he did not want
anyone in his audience who was there for the wrong reason, a hard-bitten
manager retorted that if he threw every woman out of his concert hall who

68

was there to show off her fur coat, he would have to shut down the institution the next day.

What is *not* defensible is for an arts organization to *ignore* the fact that some of its audience attend for other than ideal reasons. The institution must not abandon its responsibility to help everyone discover and experience the full range of enjoyment and enrichment the arts offer. The institution must not simply take the money and run.

A LOVE AFFAIR WITH AN EMPTY SEAT?

In the early 1980s, a professional ballet company in a major city decided to book Mikhail Baryshnikov and his dancers as a gala fundraising benefit. The event was promoted with predictable hoopla and the board was enlisted to develop all of the obligatory accompanying social events. As a means of increasing the company's subscription sales for the coming season, the purchase of tickets to the Baryshnikov benefit was tied directly to the purchase of subscriptions. You couldn't buy the star without "subscribing now."

To everyone's delight, it worked. The benefit sold out, there was an appropriately large financial return and the ballet company found itself with more than 700 new subscribers for the coming year.

As the season progressed, however, the euphoria of a new season-ticket sales record turned to increasing gloom among the artistic and administrative staffs, not to mention the dancers. The seats that had been purchased by the new subscribers were largely going empty. The buyers didn't care about wasting the money they had spent on the season tickets as long as they saw and were seen at the social event of the year.

Two years later, the board of trustees proposed an encore for the Baryshnikov affair. All right, said the company artistic director, as long as buying a subscription was not required in order to get into the big bash. He didn't like his company playing to empty seats during the regular season.

Nothing doing, said the board. They didn't care if there were bodies in the seats or not as long as there was money in the till. Apparently nobody cared that dancers find it difficult to create love affairs with empty seats.

69

From Danny Newman's gospel of DSP and from the latest commercial marketing techniques there is much to be learned and much to draw upon in the search for audiences for the arts. But both have limitations, and the undiscriminating application of their principles can be dangerous to the very essence of art. The governors, managers and patrons of arts institutions—the beachcombers—must not forget why those institutions exist, must not come to think of success in marketing, sales, subscriptions, membership campaigns, earned income, grants, big attendance figures, and efficient management systems as both means and ends.

The arts want commitment from their audiences—from *broader* audiences—but commitment by itself is not an end. And commitment for the wrong reasons is not commitment at all.

Institutions want to survive, but survival by itself is not an end, for survival is not survival at all if artistic vision is changed or lost or discarded in the process.

We believe that the beachcombers have wandered too far from the sea and have lost sight of its majesty, its mystery and its magic. It is time to turn back and explore the beach further, to remind ourselves why the arts do what they do, to search for new directions to help do it better.

We believe the new directions are there. Waiting on the beach.

WAITING IN THE WINGS

RANDOM HOUSE, INC.

ACT

THE FUTURE

THREE

SELL NOW! SUBSCRIBE LATER!

Linda Twiss unlocked the oak door to the ticket office of the Saint Paul Chamber Orchestra and let herself in. The early morning sun was streaming through the tall, third-floor windows of the Landmark Center, the restored federal courthouse facing downtown Rice Park where the orchestra had its offices. She shut off the answering machine and turned over the page of the calendar on her desk to Friday, May 9, 1980.

It should be an interesting day, she thought, with the big news about Pinchas Zukerman. The orchestra had held a media

luncheon at the Saint Paul Athletic Club the day before to introduce the brilliant young violinist as the new music director of the orchestra, replacing Dennis Russell Davies, who had left after eight seasons to head the Stuttgart Opera in Germany. The story had been on the evening television news and was on the front page of both the Minneapolis and the Saint Paul morning newspapers. She expected a lot of subscribers would be calling just to talk about Zukerman and how his appointment might affect the orchestra.

Twiss took a special interest in the subscribers to all three of the series that the chamber orchestra offered. Even though she was in charge of the whole box office operation for the orchestra, she had been part of the subscription department at the Guthrie Theater in Minneapolis for nearly five years and still believed that season-ticket holders ought to be treated like members of a big family.

She began to listen to the messages on the answering machine. The first few were routine queries and orders, and she made appropriate notes for the box office staff. Then one caller wanted to know if there would still be three different series next year with Zukerman running things. Twiss made a note to call the woman back to assure her that there would be.

She felt the subscribers would eventually see quite a difference in the way Zukerman programmed the series from what Davies had done. Davies had arrived on the Saint Paul scene in 1972, a 26-year-old conductor from the Juilliard School with very long hair, a motorcycle and a lively interest in contemporary music. He had caused a considerable stir among more traditionalist members of the audience.

Davies and manager Steve Sell had devised the three-series concept for the orchestra. The *Baroque Series* was accessible, traditional programming for the most part, played at several churches and synagogues in various parts of Minneapolis and Saint Paul and their suburbs. *The Capital Concerts* were the centerpiece of the orchestra's offerings, combining music of the baroque and classical periods with some romantic music and always a contemporary piece or two. The third series, called *Perspectives* and performed in the contemporary ambience of the Walker Art Center, was all contemporary and new music, some of it commissioned by the orchestra.

To help his audiences cope with what some considered to be his radical taste, Davies usually held an hour-long lecture demonstration in an adjacent recital hall before each Capital Concert and, at the concert itself, often discussed the contemporary pieces before performing them.

76

Twiss felt that Zukerman, coming from a more traditional background in music, would eventually make substantial changes in the orchestra's programming, even though he had announced his intention to continue the three basic series in his first season as music director. She was certain that at least some of her subscribers would welcome Zukerman's traditionalism.

She pushed the button on her answering machine and moved on to the next message.

"This one is for Linda," said the male voice, identifying himself by a name that Twiss recognized as that of a subscriber of several years standing. "Some of us were sitting around talking after we heard the news about Zukerman on TV tonight. And we're a little bit concerned. We're afraid he might stop doing some of that contemporary music that Dennis used to play, and we just wanted you all to know that we don't want that to happen."

The message on Linda Twiss' answering machine that May morning expressing concern that Pinchas Zukerman might abandon contemporary music was not the only one of its kind that the Saint Paul Chamber Orchestra received after the announcement of the change in music directors. Although, as Twiss expected, some traditionalist members of her audience did express relief at the probability of a more conservative approach to programming by Zukerman, there was an almost equal number of calls in support of continuing Dennis Russell Davies' emphasis on the contemporary.

Although it had taken eight seasons, Davies had managed to help many members of the audience find enjoyment in exploring with him new music and contemporary sounds and forms. With the help of manager Sell's imaginative promotion efforts, many new people had been drawn into the orchestra's world through the *Baroque Series*, then some had moved along to the more adventurous *Capital Concerts*; and finally, some of those had been enticed into trying the contemporary *Perspectives*.

This "system" of audience development evolved almost accidentally. But even though it was never orchestrated as fully as it now seems evident it could have been, it achieved a certain amount of success. Looking at what the Saint Paul Chamber Orchestra accomplished during Davies' tenure, it is possible to see the outlines of a plan, a new strategy for audience development.

In our definition, audience development is the long-term process of encouraging and assisting an audience member to become increasingly more involved in the life of an arts institution. The goal is to build a loyal and committed audience with an appetite for adventure. The system must provide people with the opportunity to learn about the art form and in-

77

crease their commitment to the organization at a natural, gradual pace. People learn and grow by layering one new experience on top of another. Eventually they develop a depth of understanding that allow them to open up to new and strange ideas, situations and environments. They begin to alter their perceptions, to develop new insights, to grow and change. New discoveries and new adventures stimulate their sense of curiosity, their desire to explore and discover further.

As the experience of the Saint Paul Chamber Orchestra has shown, an arts organization's audience development strategy should allow and encourage this kind of audience growth to take place. It should be a system of events and activities that provides *stepping stones* for people to increase gradually their interest, understanding and adventurousness. And in that system, the attendance at artistic events needs to be layered with participation in learning experiences. It should provide opportunities for increased *commitment* to the organization along the way and include a communications and promotional strategy that encourages people to take the steps that lead toward full commitment. We call this system the *Strategy to Encourage Lifelong Learning*, or SELL.

The basic concept of SELL is illustrated in Figure 1. It begins by introducing new people to the organization for the first time at the place that is the most accessible aesthetically and/or geographically, the most familiar and the least intimidating.

We call this place the *Point-of-Entry*.

In order to develop involvement and commitment from new audiences, there is another key element in this audience development strategy: the capturing of names and addresses at the Point-of-Entry. When subscriptions are the primary Point-of-Entry, this is done automatically, since the organization records this information as new subscribers sign up. When single events serve as primary Points-of-Entry, the importance of capturing the names and addresses of ticket buyers is too often overlooked. Yet if the long-term goal of developing loyalty and commitment is to be achieved, the development process must be a personal one. It must be carried out by mail, by phone and by personal contact. And this cannot be done unless the names and addresses of all ticket buyers are captured.

There is another reason that this is essential: cost-efficiency. New single-ticket buyers for Point-of-Entry events are reached initially through *external communication*—the media and other commercial marketing techniques—and this is relatively expensive. But once names and addresses have been captured, the process of increasing the involvement of new people can be carried out through *internal communication*—which is less expensive and much more cost-efficient than external means.

Bringing new people into an arts institution at Points-of-Entry through *external communication* is essentially increasing the organization's *reach*, or

WAITING IN THE WINGS

BASIC AUDIENCE DEVELOPMENT PROCESS

POINTS OF ENTRY

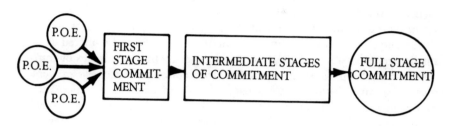

EXTERNAL COMMUNCATION	KEY TO INTERNAL COMMUNICATION	INTERNAL COMMUNICATION	
• ADVERTISEMENTS (PRINT/BROADCAST) • PUBLICITY • PROMOTIONS • SELECTIVE DIRECT MAIL (OUTSIDE LISTS)	• NAME CAPTURE*	• LETTER/BROCHURE TO NEW NAMES • TELEPHONE • LIMITED ADVERTISING • PROMOTIONS • LEARNING PROGRAMS • CONTINUOUS DIRECT MAIL	• LOBBY DISPLAYS • DIRECT MAIL TO ENCOURAGE 1ST STAGE COMMITMENT • GENERAL, BUT LIMITED ADS

GENERAL PUBLICITY ONGOING ⟶

the total number of different people who attend one or more of its events in a year. Expanding and deepening the involvement of members of the audience "family" in the life of an institution through *internal communication* is increasing the *frequency* of participation. The ultimate goal of SELL is to keep both reach and frequency growing.

After people enter the world of the arts institution at the Point-of-Entry and their names, addresses and phone numbers have been captured, the institution can then begin the process of encouraging them to participate in the various stepping stones leading to some basic *First-Stage Commitment*. That first commitment may be the purchase of a subscription to the pops or "discovery" series, or a membership, or some other kind of multiple participation.

Beyond First-Stage Commitment, the system must provide for continuing learning experiences layered with other artistic events that lead the individual to the *Intermediate Stages of Commitment*. These may include subscribing to the organization's "classics" or main series or other, larger

79

expressions of commitment, along with the possibility of volunteering and contributing. Eventually the organization will want to encourage the audience member to take the final, major step—a *Full Commitment* to the institution and its mission, however the organization may define that.

Throughout the entire process, layers of new experiences that allow audience members to deepen their understanding of the art form must be gradually, but continuously, added. Creative learning programs that are challenging, but also interesting and entertaining, need to be offered as smaller stepping stones leading to the first and intermediate stages of commitment. Full commitment, in the SELL concept of audience development, means that an individual is participating in all the activities of the organization, including its most adventurous work. However, a genuine allegiance to the organization's vision and artistic mission might occur in the intermediate stages, with the full commitment at a future time embracing such other expressions of dedication as volunteering, contributing money and, perhaps, joining the board.

The system or strategy that an organization devises must be tailored to its own mission and its particular needs for artistic development and growth. It may involve grouping different kinds of artistic events into different, increasingly adventurous packages. It may include special learning experiences designed to meet the needs of particular segments of the audience. Commitment to the organization may be arranged in progressive stages. But, in any case, there must be a plan, a formal strategy. Without this, the organization *has* no audience development program.

In proposing this approach to the new challenges of audience development, we are not suggesting that the arts abandon subscriptions, press-agentry and appropriate techniques of commercial marketing. What we are suggesting is that arts organizations reexamine the roles of those elements in light of their own original artistic dreams and visions. And, in order to make this approach work effectively, the arts must find their "success" in the enrichment of human lives rather than in increased earned income, financial stability, large numbers and the speed with which tangible, quantitative success can be achieved.

Success in the world of the arts cannot be measured quantitatively. It must be judged by the depth, impact and strength of the relationships that are developed between people and art, audiences and artists. These relationships can only be developed through a process by which people and artists learn how to communicate and share. People who are not predisposed to and comfortable with the adventure of the arts cannot be converted instantly into a committed audience. As the arts reach more deeply into the Maybes and some of the Noes for audience, they must take more time, have more patience and be more caring about helping these people

to overcome their intimidation and uncertainties and take a chance on exploring new horizons.

The time has come for the arts to remember the real reasons they are interested in audiences in the first place. They must reexamine the process by which they have been developing audiences and summon the courage to make the changes necessary to move ahead once again in reaching more new people. If the Maybes won't buy into the current system, then the choice is clear: change the system or forget about larger and more democratic audiences.

Even Danny Newman himself believes that there comes a time in the life of an arts institution when it needs to begin looking *beyond* DSP for new ways to reach new audiences. In his book *Subscribe Now!*, he writes, "In most performing arts projects, the artistic directors and managers are all in favor of increasing the variety of backgrounds represented in their audiences. If traditional promotion techniques and large-scale subscription-selling efforts have failed to produce an audience which is a true cross-section reflection of society, it is this guaranteed box-office income [from subscriptions] which allows us to explore other less traditional ways of reaching out for new audiences. Healthy subscribership has been partially responsible for a number of innovative development programs throughout the U.S. For without the security of our subscribers, we could not afford to turn our energies to such outreach projects.

"We should certainly continue to explore innovative ways to communicate with more elements of society and to diversify our audiences. [Emphasis added.]"[1]

We concur.

Subscriptions are now seen as the most effective way of attracting new people to the arts and wooing them to an instant, long-term commitment. The promotion of single-ticket sales is viewed as inefficient and wasteful except as a method of producing revenue from popular specials. But clinging to those viewpoints blinds the arts to the new directions in audience development that will enable them to reach the Maybes.

Under a fresh, new approach, single-ticket promotion to special events and to the more popular fare within a regular series can be the most effective way of attracting new Maybes to the arts for the first time. Buying a ticket to one event is a small, first step. Subscription is another, later step, a way of *eventually* getting the Maybe to make a greater commitment to the organization. The message should be, "Subscribe later!" not "Subscribe now!"

OPENING THE DOOR AT THE POINT-OF-ENTRY

October 28, 1984, in Tucson, Arizona was the kind of day that the Visitor and Convention Bureau likes to promote to winter visitors. The sun was beaming, and just a hint of fall was in the air. Halloween was only three days away, and a number of organizations were sponsoring pre-Halloween activities in parks and community centers, restaurants and hotels.

Tony and Nancy DeFeo had decided just the day before to bring their two-year-old son, Aaron, to a Halloween picnic and concert at the Tucson Community Center Music Hall. The Tucson

Symphony Orchestra had turned the courtyard of the Music Hall into the setting for a Halloween festival. Black, orange and yellow balloons floated from posts and trees and from the wrists of clowns, goblins and space creatures.

Celebrities from the local television stations and the University of Arizona's sports teams were enthusiastically carving jack-o'-lanterns as a crowd of costumed children gave pointers and cheered them on.

On a knoll at one side of the courtyard, in front of a sculpture, sat a round, jolly-looking man with a long beard, surrounded by costumed children of all sizes. He was telling a story and everyone was helping. The storyteller was taking these children (and their parents and grandparents, too) on an imaginary ghost hunt. They looked behind imaginary trees and under bushes, and they traveled across make-believe streams. Aaron had joined them and thought that this was a great game, but soon he began to wonder when the costume contest would begin.

"The judging will start in ten minutes," announced a tall red, green and orange parrot, the chairman of the event. Aaron joined the line for costumes with a musical theme. He was very proud of his outfit, but his mother, Nancy, was even prouder.

The day before the picnic, she had asked Aaron what he wanted to be for Halloween. Aaron thought for only a second before he peered up at his mother and told her he wanted to be a conductor. At first she was surprised, but he had been fascinated with the pops concerts in the park the summer before. She and her husband had taken him to the park for a picnic where the concerts were being held. They hadn't expected Aaron to express any interest, but he had dragged them up to the front row and had become transfixed by the conductor and his orchestra. Nancy went to her sewing machine and made a very small tail coat with a very small black tie for her son.

Aaron was handed a number by a contest organizer and waited patiently for the contest to begin. When they called for all contestants in the musical theme category, Aaron, waving his baton, pranced by the judges dressed in his conductor's suit and his "official" conductor's red sneakers. And when they announced the winners, Aaron was awarded first place.

Later, in the concert hall, Aaron and his parents found seats near the front of the stage and watched the orchestra members tune up. They were all dressed in costumes. The clarinetists wore pointed ears like those of Star Trek's Mr. Spock. The principal cellist looked like a gorilla and the harpist came as Peter Pan.

84

The orchestra performed music from the Disney movie *Fantasia*, Vivaldi's *Autumn* and Ives' *Halloween*. During intermission, Aaron and his father got a soft drink and sat in the lobby filling out a form for a drawing in hopes that they would win the prize, a recording of the music from *Fantasia*.

Two orchestra staff members congratulated Aaron on his prize and discovered that the DeFeos were attending their first Tucson Symphony Orchestra concert. They asked Aaron if he would like to go backstage and meet the conductor, William McGlaughlin. Aaron was delighted and instantly began rehearsing his part as a conductor to show the real one that he knew how to conduct, too.

Just before the orchestra performed its last piece, Maestro McGlaughlin looked toward the wings and spotted the two-foot-high conductor staring up at him. Excusing himself to the audience, he went to the wings, introduced himself to Aaron and the two of them walked hand-in-hand back to the podium. McGlaughlin introduced the "little conductor," whisked him up into his arms and together they conducted the last piece. As the audience and orchestra applauded their work, McGlaughlin put Aaron down on the floor and, to his surprise, the little conductor turned, thrust a small hand up toward his, shook it vigorously and turned back to the audience for a bow. Aaron then walked off stage, gave his father a huge hug and, with no prompting, turned around and walked back to the center of the stage to bow again.

A month later the DeFeos received a letter in the mail from the Tucson orchestra asking them if they would be interested in attending four other concerts in the winter and spring. That week, Nancy wrote a check for two sets of tickets.

Not everyone at the Halloween event had as memorable a time as the DeFeos, but for most it was an enjoyable, entertaining afternoon. For those attending the Tucson Symphony Orchestra for the first time, it was a happy and fun introduction to the orchestra, an ideal Point-of-Entry event.

In the Strategy to Encourage Lifelong Learning, the arts organization should designate specific Points-of-Entry each year, primarily from events scheduled for its regular season. Designating Points-of-Entry allows the organization to focus its promotional efforts and to be discriminating in introducing *new people* to its world through events that are the least intimidating or uncomfortable and the most likely to be happy, enjoyable initial experiences.

If an arts organization is *undiscriminating* about the application of its single-ticket promotion monies, it may unwittingly encourage new people

85

to enter its world at places that are strange, difficult or disturbing to the uninitiated. Those experiences may actually become "points-of-exit" that *discourage* people from returning again.

A second reason to designate Points-of-Entry is to make more effective and efficient use of available time, energy and money. Many arts groups present a large number of events in a season and often try to spread limited resources equally over the year. Frequently what results is a series of largely ineffective single-event campaigns, each suffering from severe budgetary malnutrition.

Looking for new audiences for single events is external marketing—searching outside your own family for people who cannot be identified by name but only by general characteristics. It is a "buckshot" approach to communicating with people, and it is expensive. Generally, arts organizations have limited marketing budgets. They must be wise and creative about where and how they channel limited dollars.

Concentrating those single-event, external marketing dollars on a few designated Points-of-Entry with well-defined target groups brings an organization closer to "sharpshooting," to more efficient means of reaching new audiences.

Most arts organizations offer productions or exhibits in any year that are more intellectually or aesthetically accessible than others. In the season of a theater company presenting a varied repertoire, the most obvious Point-of-Entry might be a Broadway musical or a comedy. For symphony orchestras, pops concerts may be natural Points-of-Entry. And for any performing arts organization the holiday program might be a logical choice. For a museum, an exhibition of impressionist art or a show of paintings by Grant Wood might be considered. These are the most obvious Points-of-Entry, but other programs that are accessible within the unique context of a given community may also serve equally well.

Frequently arts organizations package events into festivals or create programs based on themes, which often are designed to attract special target groups such as young adults or minorities or families. These programs can be excellent Points-of-Entry. The Tucson Symphony Orchestra's Halloween concert, for example, was created specifically to reach family audiences and those who could not attend concerts in the evenings. It was a part of the program concept developed by the music director and management. The symphony's "Afternoon Adventures" events in the series are targeted primarily at people between the ages of 25 and 40, with special attention placed on families. The programs are scheduled on Sunday afternoons and consist of light classical works centered on specific themes that appeal to a broad public. One year the themes were Halloween and Valentine's Day. In another, the programs were *Exploring the World of Aaron Copland* and *Music and the Spoken Word*, which included Prokofiev's *Peter and the Wolf*

and Copland's *Lincoln Portrait*. These programs were created and promoted to appeal to both adults and children.

Other orchestras have found success in packaging concerts around the music of a well-known composer or popular movies and their theme music. The many "Mostly Mozart" programs presented around the country are ideal Points-of-Entry. They not only interest Mozart fans, but also can attract the many people who saw the movie *Amadeus*. In the early 1980s, a concert about Vivaldi's work might have intrigued those who enjoyed the incidental music in the movie *The Four Seasons*.

Events *outside* the artistic programming of an institution may also be used as Points-of-Entry. A number of arts groups present specials that are of the same quality as their own, but of a different art form. The Goodman Theatre in Chicago presents a series of dance concerts in their theater on dark nights. For the Goodman, the dance concerts serve as a way of reaching new, younger people who eventually may be motivated to attend theater performances. In Washington, D.C. special popular events attract new people to the Arena Stage. Many museums offer music, theater and dance programs, partly as a means of introducing people to their facilities and exhibits.

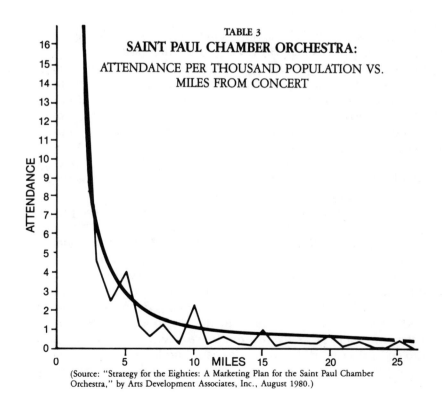

TABLE 3

SAINT PAUL CHAMBER ORCHESTRA:

ATTENDANCE PER THOUSAND POPULATION VS.
MILES FROM CONCERT

(Source: "Strategy for the Eighties: A Marketing Plan for the Saint Paul Chamber Orchestra," by Arts Development Associates, Inc., August 1980.)

87

The best Points-of-Entry have some relationship to the artistic mission and vision of the organization: they serve as the first in a carefully planned series of stepping stones leading from a tentative first sampling of the programming to a full commitment to the institutional mission. If an organization presents too wide a range of programs—from the very popular to the avant garde—then the vision will seem scattered and diffuse. New people, mystified by the lack of focus and not knowing exactly what to expect, will be discouraged from stepping up their participation.

Identifying geographic locations where it is more convenient for certain target audiences to attend events is another option for establishing Points-of-Entry. Some people will try something new if they don't have to travel too far to do it. If a performance is in their "backyard," they may be more likely to attend. In one analysis of attendance versus travel distance conducted by Arts Development Associates for the Saint Paul Chamber Orchestra, participation fell off dramatically when audience members had to travel more than five to seven miles.

CHAMBER ORCHESTRA REACHES NEW AUDIENCES BY PERFORMING IN THEIR BACKYARDS

The Saint Paul Chamber Orchestra has been offering its Baroque Series since 1971. Originally the series was presented in churches and synagogues scattered around the twin cities of Minneapolis and Saint Paul for a very practical reason—the orchestra had no permanent home. Since the orchestra's original size of 21 musicians gave it great mobility and flexibility, its early marketing strategy was built around the concept of "Music On The Move." Management sold the orchestra's services throughout the Upper Midwest and presented concerts in the Twin Cities wherever it could find an available venue.

It soon became evident, however, that concerts presented in local neighborhoods rather than in a downtown location, were attracting a different kind of concert-goer who was not a regular at traditional concert halls. This was particularly true of the Baroque Series, which, almost accidentally, became the Saint Paul Chamber Orchestra's primary Point-of-Entry for new audiences. Recognizing the efficiency of this phenomenon, the organization began to structure part of its overall audience development strategy to capitalize on it. From year to year and manager to manager, the degree of emphasis on this concept has varied

88

but it has proven its effectiveness over a sustained period of time. Geographic accessibility can be as important in attracting new audience as intellectual and aesthetic accessibility.

In some cases, consideration might be given to locating some regular performances in venues close to particular target audiences. But where that is difficult, impractical or cannot be done with sufficient frequency, arts groups can create special ensembles to present programs in target areas.

Many organizations already have outreach programs, but few of these are part of an overall audience development strategy. Most are developed to correspond with the interests of funders and/or the needs of special constituencies. Although important and worthwhile purposes may sometimes be served in this way, it is also possible to design outreach programs specifically as a means of introducing target audiences to the organization and helping them to learn more about the organization's primary work. The Affiliate Artists program has been extremely effective in providing sponsoring arts groups with opportunities to reach new audiences and build interest in the sponsor's own productions. The program provides specially-trained, individual performing artists who present "Informances," in which the performer discusses *and* demonstrates his or her art form in an informal setting (often the workplace) that is familiar and comfortable for potential new audience members.

Performing in shopping malls and other public places is fairly common. Often, however, arts groups perform in those locations for extraneous or counter-productive reasons: because they receive special funds or because they simply wish to increase their total season attendance figures for the next round of grant applications. But such events can be planned to *work* for the organization in developing new audiences. They can be placed in target areas and designed to encourage the audiences to *focus* on the event rather than simply noticing it in passing. If the programs are fun, creative and participatory, it is easier to create and sustain interest and curiosity among potential audience members.

Designating Points-of-Entry from among scheduled events is not enough. They must be sold with *at least* as much energy and money as the organization puts into selling season tickets or memberships. All the marketing activities that are normally applied to single-event sales should be increased for Points-of-Entry. The usual publicity, direct mail, and print and broadcast advertising should be expanded and reinforced, with sharp focus on particular target audiences.

In addition to the usual marketing efforts, special theme-oriented ac-

89

tivities can make an event more promotable and create a "sense of occasion." The Halloween picnic of the Tucson Symphony Orchestra was designed to attract parents who wanted to do something special for their children at Halloween. Several families attended the picnic with no intention of going to the concert, but after enjoying the festivities in the courtyard decided that they wanted to extend what had been a memorable and exciting afternoon. The huge concert hall seemed less intimidating because of the festival atmosphere and because of all the other parents entering the hall with their costumed children.

Sir Tyrone Guthrie, founder of the Guthrie Theater in Minneapolis, Minnesota, believed it was extremely important to create a "sense of occasion" for an audience. Colorful banners were hung in front of the theater. Trumpeters announced curtain times with fanfares. The performance itself was only a part (though the most important part) of the total experience or "ritual" of attendance, according to Guthrie.

KITE DAYS HELP MUSEUMS PROMOTE EXHIBITS

The Tucson (Arizona) Museum of Art presented a kite exhibit that included a number of promotions and special events. Each Saturday during the exhibition of the kites, the museum held kite-making workshops for young people. One Sunday the museum sponsored a kite-flying day, taking over a city park for a day-long festival of kite flying, contests and other events. All of these special activities served to make the exhibit a more appealing Point-of-Entry.

Laumeier Sculpture Park in St. Louis, Missouri also presented an extremely popular kite day as a Point-of-Entry event.

But it is important to remember that promotions can contribute to the long-term development of audiences only if they do not stray too far from the vision of the organization and do not overwhelm its artistic program. The goal is to make Points-of-Entry more comfortable for new people, to help create excitement, to intensify, not to distort or misrepresent, the artistic experience.

Likewise, group sales programs can serve the goals of long-term audience development more effectively if they are integrated into a total system and viewed as a *means* to an end rather than as an end in themselves. Many organizations approach group sales programs with one goal in mind —to fill seats and increase earned income. But if they are *created and designed for Points-of-Entry*, then they contribute toward the ultimate goal of

90

developing long-term relationships between people and art.

For some who find the prospect of going to the theater, concert hall or museum on their own a bit intimidating, attending with a group of friends and peers makes the idea more palatable. By focusing group sales efforts on designated Points-of-Entry, an organization can make certain that newcomers will have the best chance of enjoying themselves. Selling a new group a block of tickets to an obscure or complex work just to fill seats does not necessarily contribute to long-term goals of audience development.

Corporate sales programs can be made to function in the same way as group sales. Some are set up through company sales representatives who, if developed by the arts organization as members of its family, can be effective advocates. Yet arts organizations which sell subscription packages to corporations sometimes find many of the tickets going unused. Under these circumstances, nothing beyond earned income has been gained. An arts organization should work closely with corporations to design ticket programs that will bring new people into its world through appropriate Points-of-Entry.

Point-of-Entry programs enhanced by special events, promotions and group-sales efforts will support a long-range strategy for developing new audiences only if the names and addresses of all newcomers are captured the first time they venture into an organization's world. From that point on, the process of increasing the involvement and commitment of each audience member must become a matter of personal communication. This is necessary both from a conceptual, philosophic viewpoint *and* from a practical, financial one.

Obviously, communicating with individuals who can be indentified by name is much more cost-efficient than trying to communicate with an anonymous mass of people through advertising and promotion. If names and addresses are captured at the Point-of-Entry, then all further efforts to increase the audience's frequency of participation can be through internal, personal communication. Ultimately, an organization should do external advertising and promotion (which may include direct mail to borrowed lists) *only* for Point-of-Entry events. All other single-ticket, subscription and membership campaigns should be conducted by mail and telephone, working from the organization's *own* mailing list of family members.

The most obvious method of capturing names, addresses and phone numbers is through the box office. It is crucial that box-office personnel get that information from every person who calls or walks up to the window to purchase a ticket. Although this may appear obvious, many arts organizations do not invest the money or manpower to make this possible. When the Arizona Theatre Company began expanding in the mid-1970s, a company-run box office was installed. Previously, tickets had been sold by the city of Tucson, which owned the theater facility used by the company. As

91

then Managing Director David Hawkanson recalls, initially the organization had not been in the financial position to establish a box office; but he now recognizes that the decision to do so was one of the company's most important moves toward audience growth, in large part because it allowed ATC to capture names and addresses more effectively. The organization has grown, and in 1985 ATC improved the salaries of its box-office personnel in order to develop higher quality service and greater consistency in box-office procedures.

The box office is not the only place where names can be captured. The Tucson Symphony Orchestra has held lobby drawings at Point-of-Entry programs as well as at events in malls and other locations. Free drawings for various prizes—record albums, dinners or tickets to other similar events, for example—are a means of collecting names, addresses and phone numbers of people who attend performances and exhibits. In one season alone, the Tucson Symphony increased the size of its mailing list by 40 percent just through drawings for prizes at concerts. And many other arts organizations have had similar success.

CAPTURING NAMES AT OUTDOOR EVENTS

For many years the Houston Grand Opera presented a series of free Opera-in-the-Park performances in the summer. During several seasons the opera experimented with designating those performances as Points-of-Entry and using them to develop new audiences for its main performance series in Jones Hall in downtown Houston. Capturing names from free concerts held in a large park seemed a major challenge.

The solution was to give away a tape deck at each performance together with a tape recording of the opera being performed. But members of the audience were not simply given an opportunity to register for the intermission-time drawing. Volunteers wearing straw hats and badges and working from special booths set up around the park actively encouraged people to sign up. The drawing was followed up by writing to the people whose names had been captured in the park and inviting them to attend an extra performance of one of the more accessible operas in the main season. The approach worked. The performance sold out.

92

Group and corporate sales are another source of names. The Arizona Theatre Company sometimes offers additional discounts on tickets if the purchasing organization provides a typewritten list of the names and addresses of all the people who attended the theater as part of the group. The names go on the mailing list and the process of motivating individuals to return on their own begins.

The Guthrie Theater's corporate program provides the audience-development staff with the names and addresses of potential theatergoers. The theater recruits representatives from the businesses that participate in the program. The representatives are responsible for promoting the theater to employees and for encouraging them to apply for corporate "discount cards," good for 15 percent off the price of tickets to Guthrie productions. In order to receive the card, the employee must fill out an application form. The theater can then follow up immediately and begin encouraging applicants to take advantage of their discount cards.

ORGANIZATION "GIVES AWAY" ITS ORCHESTRA TO CAPTURE NAMES

The Saint Paul Chamber Orchestra captures names in a more unusual way than most organizations. They target a geographic area, find a local group to sponsor them and actually give the orchestra to the sponsor free of charge. The group can sell the tickets as they choose, using the performance as a benefit or giving tickets away. But in exchange for the free performance, the orchestra must be provided with the names and addresses of all people attending the concert.

The Saint Paul Chamber Orchestra is able to do this when they have extra musicians' services available, and this does not happen on a consistent basis. But the names and addresses that the orchestra collects in this manner are precious to the development of new audience members from specific target areas.

It is not enough simply to capture the names and addresses of new attenders. The organization must then begin to develop a history of every person who enters its world. Larger organizations utilize sophisticated computer systems. Smaller organizations can develop profiles of their audience

members by recruiting volunteers to keep up-to-date records on index cards. With or without a computer, the system for keeping audience records is essentially the same. Ideally, every contact or transaction an audience member has with an organization should be recorded.

The Guthrie Theater has an extensive coding system for captured names and addresses. The date that each person first attends and the specific production seen is recorded. Because the Guthrie produces a wide range of plays, each show receives a special *interest code*. For example, the code for Shakespeare plays may be an "S," for avant garde plays an "A," and because *A Christmas Carol* is presented every year, that production receives a code of its own.

By developing a history for every audience member, the organization can learn how best to develop his or her interests further, and patterns of audience activity can be discovered in order to capitalize on them.

DISCOVERING PATTERNS IN ATTENDANCE CAN HELP DEVELOP NEW AUDIENCE

In the mid-1970s, the American Conservatory Theatre (ACT) in San Francisco carried out an extensive survey of its subscribers, in part to look for patterns in the way members of the audience became committed to attendance and support of the institution.

Two clear tendencies became evident.

By far, the greatest number of season ticket-holders first subscribed to ACT after attending productions on a single-ticket basis during two previous seasons. With this knowledge, ACT could keep track of new single-ticket buyers, and after they had attended in two successive seasons on single tickets, the theater could afford to make an extra effort to convert them to subscribers because research showed they were susceptible at that time.

A similar pattern surfaced with respect to first financial contributions to ACT. The facts showed that more people made their first gift to the institution after they had subscribed for a third successive season. This meant that the development department could make a special, intensive effort to solicit contributions from a person at the time when the records showed he or she had signed up for a third year of season tickets.

Being able to identify patterns of audience behavior

and to maintain the records that allow an organization to take advantage of those patterns can greatly increase efficiency in developing audience commitment.

As names and addresses of new audience members are collected, it is important to follow up immediately and begin developing further involvement. The Arena Stage in Washington, D.C., boasts a 93 percent capture rate for the names and addresses of the people who attend the theater for the first time. Its staff developed an extensive and extremely effective system of follow-up. Within 24 hours after a name has been captured, it is put into a computer. Within two weeks, that person is called and offered a membership that includes a subscription to the theater's magazine, advance notice of special events and discounts off single tickets to some Arena productions. According to Richard Bryant, its former public relations and marketing director, Arena is able to interest five percent of the people it calls in purchasing the membership. If the person is not interested, the theater will do direct mail follow-up for up to two years, offering discounts to the kinds of shows in which the individual has shown interest. The objective of the consistent follow-up is to get a first commitment from the new person. Once that initial commitment is made, the theater will begin approaching these people for a stronger commitment, generally a subscription to a series. Over a five-year period, Arena's attendance increased by more than 50 percent.

The primary objective of establishing Points-of-Entry and promoting them intensely is to increase the total number of *different* people the organization *reaches* in a given year. Name capture at the Point-of-Entry then allows the organization to use efficient, internal communication methods to encourage those new individuals to increase their *frequency* of attendance. Ultimately, the ideal situation for any organization is to keep both reach *and* frequency growing.

Developing and promoting Points-of-Entry and capturing names and addresses are relatively simple, though critical, components of SELL. Increasing the audience's involvement with and commitment to the organization on a continuing basis over time is a more difficult, more complex process that calls for new ideas, new directions and new concepts. The arts are not dealing here with the pre-conditioned, predisposed Yeses. They are reaching out to the Maybes—people who are uncertain about and a bit intimidated by the arts, people who are not yet ready to accept the arts as an important part of their lives or to make a major commitment to something they don't quite understand.

Helping new people discover the joy and the magic of the arts, leading them toward a lifelong love affair requires understanding, imagination and patience, but most of all a caring sensitivity to their needs, fears and desires as human beings.

WAITING IN THE WINGS

LONGING FOR INSIGHT AND KNOWLEDGE

11

The musicians were still packing up their instruments and the fans still congratulating piano soloist Paul Badura-Skoda as a small group of audience members made their way to the back-stage green room of the Tucson Community Center Music Hall. Julie Dalgleish, then director of audience development for the Tucson Symphony Orchestra, greeted them, inviting them to help themselves to a glass of wine and gather around a table.

When a dozen or so had arrived, Dalgleish began the informal meeting. Maestro William McGlaughlin would join them as

soon as he changed clothes, she explained. "In the meantime, perhaps we could begin by going around the table and finding out what each of you thought of the concert tonight. And be really honest about it."

The group had met with Dalgleish previously on an afternoon two weeks before to participate in one of the *focus group* discussions she was conducting as research for a long-range audience development plan being created for the orchestra. These particular people had been identified and invited to the original meeting as "non-attenders" of concerts in Tucson. As the discussion unfolded, that non-attendance proved to be generally true, although several had been to one Tucson concert previously, and a few had attended a performance or two by symphonies in other cities. But basically, Dalgleish had concluded, the participants at her meeting were definitely members of the Maybe category of potential audience. They seemed a little intimidated by the idea of going to concerts. They didn't feel they "knew enough about music" to really appreciate it, they told her. As they talked, she decided to invite them to the next concert of the Tucson Symphony Orchestra and then to meet afterward to discuss how they had enjoyed it.

"Boy, that last piece was sure long," one of the women was saying as Dalgleish continued to go around the table asking for comments. "I thought it was going to end about six times, and then he'd begin all over." Others laughed and echoed their agreement. "I actually put on my sweater once and got my purse out from under the seat when I thought it was nearly over," said another woman. "And then it started again."

The last piece had been Anton Bruckner's Symphony No. 4 in E-flat Major ("Romantic") which had lasted about 66 minutes. The program had also included *Air on the G String* by Johann Sebastian Bach and Mozart's Concerto No. 24 in C for Piano and Orchestra.

By this time, Music Director Bill McGlaughlin had come into the room. "I'll admit the Bruckner was a bit long," he said, joining the group at the table. "But the question is, did you enjoy the rest of the concert and would you come back again?"

"Not if you're going to play more boring stuff like that last one," said one of the men. "The rest of the music was all right, but I didn't understand that Bruckner thing at all, and it just seemed to go on forever."

"You'd have a tough time getting me back again if I thought there was going to be another one like that to sit through," commented another.

98

She had managed to get them into the concert hall, Dalgleish thought, but Danny Newman's "vaccination" certainly hadn't taken with this group.

"How many of you have ever been up to Gates Pass to watch the sunset?" McGlaughlin asked. Most raised a hand indicating they had visited the popular lookout point in the desert west of Tucson. "You know how, when you look out to the south and west, the desert goes on for a long, long time, and then suddenly there's a range of mountains rising up. And then that flatness again for miles, and suddenly more mountains beyond. A different shape. A different color. Layers of spectacular mountains separated by long stretches of the desert with all that fascinating vegetation and subtle color. Well, that's sort of the way I think about Bruckner's Fourth Symphony, with a lot of long, subtle space in between great peaks of sound."

McGlaughlin talked on, spinning out an analogy between the beauty of Arizona's deserts and mountains and the shape and feelings of the Bruckner that kept the group spellbound. He loved Arizona and had hiked many trails in the mountains and canyons around Tucson. He called them by name and spoke of specific cactus and desert flowers, animals and birds as he tried to relate familiar feelings and experiences with nature to the feelings he felt about the music they had just heard.

When he finished there was silence for a moment, and then one of the men spoke up. "You know, Bill, if you had only told us that *before* we heard the music, we probably would have enjoyed it a lot more."

Probably, the "vaccination" still hadn't taken with Dalgleish's group of Maybes at that concert of the Tucson Symphony Orchestra, although their conversation with Maestro McGlaughlin may have made them less intimidated by the thought of returning another time. Without his eloquent attempt to help them understand more about the Bruckner Symphony, it seems doubtful most of the group would have come back soon for the ordeal of being vaccinated again. Ahead of time, they had thought they didn't "know enough" to enjoy symphonic music, and their fear was largely confirmed by experience.

Evidence that potential arts audiences feel inhibited and intimidated by lack of knowledge comes from many sources beyond the Tucson Symphony Orchestra focus groups and seems to be surfacing more and more frequently in audience research. It appears to be a key factor in differentiating between the Yeses and the Maybes. The fact that the desire to know more is heard most often from casual and infrequent attenders corresponds with the idea that the arts have largely exhausted the supply of Yeses and

are finding it necessary to push more deeply into the Maybes to expand their audiences.

Of the three demographic characteristics that most precisely define cultural audiences—education, affluence and professional/managerial occupational categories—education is generally accepted as the most influential because it is usually a prerequisite to the others. As the arts push beyond the limits of the relatively small group of Yeses, it is logical that the first barrier to expanded audiences is an educational one. In potential audience members it surfaces as *the need to know more* in order to appreciate.

In the early 1980s, the Houston Symphony Orchestra carried out extensive research on its present and potential audience. One section of the report said: "Houston audiences, especially single-ticket and infrequent patrons, appear to hunger for more knowledge about classical music. In the group discussions, the interest in knowing more about composers and their works ranged from polite to extreme interest. Although Houston audiences may not be perceived as coming from a deep musical tradition, they express a fervent need for information to extend their education."

The thirst for knowledge among audience and potential audience is not limited to those interested in symphonic music. In a series of focus group discussions carried on by the Guthrie Theater, the consensus was well summarized by one man's straightforward statement: "The biggest thing the theater can do for us is give us information." Said another participating member of the audience: "The Guthrie is more than entertainment. It is continuing education. We must try to understand what they are doing." The report summarizing the research stated: "Linked to the information need is the thought that play enjoyment/understanding can be increased and dissatisfaction decreased by preparing people to see a production."

In 1985, the Mid-America Arts Alliance convened a distinguished national panel representing a variety of artistic disciplines and presenters of performance events. Their assignment was to advise the regional arts agency on developing greater acceptance in their five-state area for more adventurous touring performances. Their consensus was simple: audiences want and need to know and understand more in order to feel comfortable with unfamiliar or nontraditional kinds of performances.

Says Rex Moser, former director of education for the Art Institute of Chicago and now an exhibit field manager for the United States Information Agency, "People are *demanding* to see how the evolution of art fits into history—its context—because it helps them appreciate it."

The cynic may grumble that "I don't know enough" is merely a convenient excuse for ennui, disinterest or lack of taste. As one manager put it during the question-and-answer session of a seminar on audience development, "I simply don't believe that most people want to learn anything about the arts. All they're interested in is entertainment."

To the idealist, expressions of interest in "knowing more" are signs of hope for the future development of audiences and further reason to believe fervently in the statement made by Leonard Bernstein in the introduction to his book *The Joy of Music* that "the public is *not* a great beast, but an intelligent organism, more often than not longing for insight and knowledge."

Many purists among artists, curators and artistic directors are uncomfortable with the notion that anybody has to *know* anything in order to appreciate any kind of art. They believe the experience of art itself transcends rationality and communicates regardless of an audience's state of experience, knowledge or sensual awareness. They resist—often strongly—suggestions that their institutions develop programs for the education of audiences and dig in their heels at the idea of talking about or trying to explain art. In discussing why his museum of contemporary art did not supply visitors with audio devices for exhibitions, the director of education said, "Our curators believe that the audience already knows what is necessary and that you don't have to teach them anything."

The education director of another contemporary museum, however, had a different viewpoint. "Knowledge," she said, "can quicken appreciation, help make the experience more important and open up attitudes." The idea of opening up attitudes toward new ideas and experiences that challenge the mind and the imagination seems particularly important in helping people to feel comfortable with the arts.

For every artistic leader who finds the idea of educating audiences objectionable, there is probably another who acknowledges that it is desirable for audiences to acquire some kind of background to help them find greater enjoyment in the experience of art. Many will also accept the need for artists and arts organizations to participate in providing audiences with knowledge beyond whatever they have managed to pick up through formal education. But for many who accept this need in principle, there is still a certain wariness about actually confronting it.

Nigel Redden, general manager of the Spoleto Festival in Charleston, South Carolina and former director of the Dance Program at the National Endowment for the Arts, observes that "if an artist's work can only exist with a lot of explanation, then it should probably not exist." But he goes on to say that "audiences want and need greater knowledge of the *context* in which dance exists." The context in which art exists or is created is a concept often used by artistic leaders in describing what they feel is valuable for an audience to understand.

Understanding and appreciating what an artist is, what he or she does and why is also something many artistic leaders believe is valuable to an audience, although there is ambivalence here as well. "Old-time managers, and even some still operating today, believe that you should keep artists

101

away from society, separate them," observes Richard Clark, who has been president of Affiliate Artists, Inc., almost from its inception in 1966. "They think the mystique has to be protected. Now, I believe that with a truly memorable aesthetic experience you feel exhalted, elevated, lifted out of yourself and that it transcends anything rational. But the reason Affiliate Artists places artists in communities to do the 'Informances' that combine talking and performing is because we not only believe but *know* that if an audience can relate the life and goals of an artist to their own lives and goals, they will open themselves up more fully to the possibility of that memorable aesthetic experience happening."

Dr. Steven Cahn is a musician, teacher, educational philosopher and provost of the Graduate School of the City University of New York. He refutes the position that an audience need have no information or background to appreciate an aesthetic experience. In an unequivocal statement he says, "It is demonstrably false that the person who knows nothing can get as much out of something as someone who knows something.

"Your chances of liking something," he says, "are related to how much you know about it. It is a strange view to think that it doesn't help to understand a subject. It would be like reading a book in a language you don't understand. . . . If you send two different people to see *Waiting For Godot* and one of them knows something about theater and the other one doesn't, the one who knows is going to get the most from it. Why keep art a mystery?

"The failure to teach art in the schools is a great loss. Yes, the arts are on a plateau [with respect to audiences]. They have reached as far as they can without doing something more about helping people understand."

The ambivalence many artistic leaders feel about the need to educate audiences and the outspoken opposition of some to becoming involved in the process at all seems to originate with one or both of two fears at opposite ends of the spectrum. On the one hand is the fear the word *education* itself strikes in the hearts of many artists—the horror of *over-intellectualizing* art and making it as boring and academic as they believe the schools and colleges do.

At the other extreme is the equally terrifying specter of *over-popularizing* art and somehow cheapening or demeaning it. At the heart of that dread is the suspicion that press agents, marketers and directors of audience development will use education as a front for hustling audiences. In an interview about their educational programs with Joseph Melillo and Roger Oliver of the Next Wave Festival at the Brooklyn Academy of Music, the two made it very plain that their job was *not* to promote audiences but to pioneer a new kind of popular scholarship. They are not, they said, generating audiences but helping audiences to understand. "We want to create interest through knowledge, not hype." The goal is one to be cherished.

The fear is that something called "education" has to be either boring academia or demeaning hype. Leonard Bernstein believes otherwise.

During the 1950s, when he was music director of the New York Philharmonic, Bernstein won critical and public acclaim for a series of radio and television programs he created and narrated to help people understand music. For a whole generation of Americans of all ages, Bernstein opened the door to the love of music through a remarkable blend of entertainment, humor and scholarly integrity few have been able to duplicate. To many who work in the arts, Bernstein's accomplishments during those years are legendary, and there is an awe about his genius for teaching that seems to have intimidated others into a fear of trying to go and do likewise. The explanation of what he tried to accomplish with those programs found in the introduction to his book *The Joy of Music* demonstrates how audiences can be assisted in learning about art without being hopelessly bored or helplessly hyped.

Bernstein discusses the difficulty of trying to shed light on the mystery of music. There is, he says, "a human urge to clarify, rationalize, justify, analyze, limit, describe. There is also an urge to 'sell' music, arising out of the transformation of music in the last 200 years into an industry. Suddenly there are mass markets, a tremendous recording industry, professional careerists, civic competitiveness, music chambers of commerce. And out of this has come something called 'Music Appreciation'—once felicitously called by Virgil Thompson the 'Music Appreciation Racket.' "[1]

The "racket" operates in two styles, according to Bernstein—Type A and Type B—and one is duller than the other.

"Type A is the birds-bees-rivulets variety, which invokes anything at all under the sun as long as it is extra-musical. It turns every note or phrase or chord into a cloud or a crag or a Cossack. It tells homey tales about the great composers, either spurious or irrelevant. It abounds in anecdotes, quotes from famous performers, indulges itself in bad jokes and unutterable puns, teases the hearer, and tells us nothing about music. I have used these devices myself. But I hope I have done it always and only when the anecdote, the analogy, or the figure of speech makes the music clearer, more simply accessible, and not just to entertain or—much worse—to take the listener's mind *off* music as the Racket does.[2]

"Type B is concerned with analysis—a laudably serious endeavor, but it is as dull as Type A is coy. It is the now-comes-the-theme-upside-down-in-the-second-oboe variety, a guaranteed soporific. What it does, ultimately, is to supply you with a road map of themes, a kind of Baedeker to the bare geography of a composition; but again it tells us nothing about music except those superficial geographic facts."[3]

Bernstein further discusses each type and concludes that musical analysis for the layman is extremely difficult.

"Obviously we can't use musical terminology exclusively, or we will simply drive the victim away. We must have intermittent recourse to certain extra-musical ideas, like religion, or social factors, or historical forces, which may have influenced music. We don't ever want to talk down; but how *up* can we talk without losing contact? There is a happy medium somewhere between the music appreciation racket and purely technical discussion; it is hard to find, but it can be found.

"It is with this certainty that it can be found that I have been so bold as to discuss music on television, on records, and in public lectures. Whenever I feel I have done it successfully, it is because I may have found the happy medium."[4]

We also believe that, somewhere in between the "appreciation racket" and purely technical discussion, a happy medium can be found for learning experiences in all artistic disciplines. But the creation of lively, innovative, substantive new programs requires a close and understanding partnership between artistic leaders and artists on the one hand and those who promote, manage, govern and fund the arts on the other. Through this kind of partnership, arts organizations can create a new genre of learning experiences for adults that will allow the arts to continue their move from the periphery of society toward the center.

There are some who firmly believe that educating people to an appreciation of the arts is primarily the responsibility of the schools. The arts, they say, need not become involved beyond providing opportunities and resources that enable the educational system to expose young people to the arts in the context of school curricula.

For two reasons, we believe this to be a flawed and short-sighted point of view. First, there is little evidence that the concept works and even less that it can be expected to change for the better in the future. Since the 1960s there have been well-publicized, enthusiastic and often well-conceived efforts to "make the arts more central to the school curriculum." Government agencies both in the arts and in education have developed many imaginative programs on behalf of improved arts education, and at times, substantial state and federal funding has been applied to implement them. Generally, arts organizations and foundations have supported and cooperated in such efforts, providing a multitude of resources and programs to assist the schools. Without question, some of those efforts have produced exciting results and many seem well worth continuing.

And yet the arts today appear to be *less central* to the curricula of American schools than they were three decades ago. There is almost no attendance or audience composition data to suggest that school programs have resulted in the development of larger or broader adult audiences for the arts on a continuing basis.

104

There is even reason to speculate that, since World War II, changes in the nature of education at both K-12 and college levels may be resulting in a *smaller* proportion of Yeses among today's youth and young adults than in previous generations, perhaps portending *declines* in attendance. As the arts decentralized and proliferated in the 1950s, 1960s and 1970s most of the new audiences were people educated before World War II. By the end of the 1980s, the majority of those in active age brackets will have been educated *after* the war. If, as some speculate, there has been a significant decline in the quantity and quality of liberal arts education and in the teaching of the critical thought process so important to acceptance of the arts, then there may be *fewer* Yeses predisposed toward participation in the arts in the future than there were in the past. If that should prove to be the case, the arts may find themselves fighting to stay even in attendance rather than being concerned with future growth.

ARE THE YESES A VANISHING BREED?

In 1955, in one of the earliest such projects on record, the Minneapolis Symphony Orchestra (now the Minnesota Orchestra) retained a market research firm to conduct a survey of its audiences.

Among other findings, the research showed that the median age of the audience at that time was about 33 years. In April 1985, a comparable study was done. The median age was about 48 years.

In 30 years, the median age of the audience had increased by 15 years, while the median age of the population in the U.S. rose only about one year. It appears very likely that much of the audience is the same people grown older.

If so, those "retiring" from the audience are not being replaced by an equivalent number from the younger generations, and it would appear that the proportion of Yeses among the young is smaller than it was several generations back.

Could it be that the Yeses are a vanishing breed?

Even if the schools were *increasing* their emphasis on the arts and improving their ability to develop lifelong interest among a substantial proportion of their students, there is a second reason why the arts should not abdicate all responsibility for educating adult audiences.

With increasing insistency since World War II, educational leaders have been emphasizing that learning should become a lifelong experience that does not end with acquiring a diploma or finding a job. The *process* should be the goal, they suggest, rather than a means to some other end. Learning itself—exploring, being challenged, puzzled and surprised, discovering, growing—should be a source of enjoyment rather than medicine to be taken as a cure for ignorance or a punishment to be endured to master a trade.

One of the strongest and most eloquent expressions of this idea came in the report of the National Commission on Excellence in Education issued in 1983. It suggested that the value of learning is not contingent on any material payoff but that the activity itself pursued throughout one's lifetime *is* the payoff. The principal objective of educational reform, the commission suggests, should be the creation of a "learning society" devoted to the joys and rewards of continuous learning as opposed to the accomplishment of any one-shot objective.

As idealistic as this concept may appear in our achievement-based society, it seems wholly compatible with the supposedly fundamental reasons that the arts exist: as a means of exploring, understanding, interpreting, and enriching human experience. For an audience, the *process* of discovering and exploring, of being challenged and puzzled and surprised, of growing in their involvement with art—can in itself be a source of enjoyment and should be the objective of an arts organization's audience development philosophy, distinct from the year-to-year need to sell tickets and increase earned income.

Accomplishing this end cannot be left to chance, or to educators alone. The arts can and must make their contribution to the development of a "learning society," through conscious, creative, long-term efforts. In the book *A Place Called School: Prospects For The Future*, author John I. Goodlad calls for a new coalition, which "must embrace new configurations in the community that include not only home, school, and church, but also business, industry, television, our new means of information processing and all the rest of the emerging new technology of communications, and *those cultural resources not yet drawn on for their educational potential. Education is too important and too all encompassing to be left only to schools.* [Emphasis added.]"

We believe that *only* through a major commitment to new and imaginative ways of helping audiences to make learning a lifelong process can the arts reach beyond the Yeses into the Maybes and Noes and move beyond their present plateau of attendance.

WAITING IN THE WINGS

WAYS TO DISCOVER

"I just didn't understand any of that modern stuff, Ma'am. I mean, I couldn't figure out what was so great about it, y'know? I figured anyone could paint like that, even me."

Julie Dalgleish was sitting next to the window on Republic flight 454 taking her from Minneapolis, Minnesota to Memphis, Tennessee one August day; and her seat-mate, a man in his late thirties from Chattanooga, was telling her about his first experience with contemporary art.

"A couple years ago, I went to New York City, and a lot of folks I know, they told me I should go visit this modern museum, y'know? They said that this museum had some pretty good art there by some really famous artists. So I figured I might as well give it a try."

He had visited the Museum of Modern Art on his trip, but his experience there was not a very positive one. He had been especially taken aback by the abstract paintings, never having seen that *kind* of art before.

The flight was about halfway to Memphis when the man first struck up a conversation with Dalgleish. He had been to Minneapolis for a computer salesman's convention, he told her in a thick southern accent, then asked her where she was going and why, what she did for a living and if she had ever been to Chattanooga.

"We have a lot of culture in Chattanooga, Ma'am." He had been born and raised in Chattanooga, still lived there and was proud of it. He began to tell Dalgleish everything he knew about the arts in his hometown as well as asking her questions about her career in the arts.

"We have a theater that does some good plays, I hear. But I haven't gone to see any yet. Chattanooga also has a ballet and symphony orchestra." He hadn't actually been to performances of those organizations either, but he did seem to be fairly knowledgeable about them and had some interest in the arts.

"Now, we have a really great museum in Chattanooga, Ma'am. I mean I *have* been there and I even took one of their classes."

The Hunter Museum offers a series of art classes, he told her, in pottery making and portrait painting as well as in sculpture, watercolor and oil painting.

"I got this flyer from the museum that advertised all their art classes. It was right after I got back from that trip to New York City. Well, I thought why not take one of the painting classes? After all, I figured *anyone* could paint like those famous artists at that Museum of Modern Art. It didn't look like it would be too hard, so I signed up."

"How many times have I heard this story before?" Dalgleish wondered as the man continued to talk about his art class. It's funny, she thought, how many people think they can just walk into an art class and be instant masters. Perhaps some contemporary art *looks* easy, she mused, but how do you get them to really understand?

"But let me tell you, Ma'am, that wasn't easy. I mean, it was tough." Dalgleish was shaken from her thoughts as the com-

puter salesman continued his story. "I tried and tried to paint some of those pictures, but I just couldn't do it, at all! It's just not anywhere as easy as it looks. I tell you, I got a lot more respect for those modern artists now. I mean, now I want to go back to that museum in New York some day and take another look. Because now, y'know, I think I might really be able to appreciate some of their stuff a whole lot more! Y'know what I mean?"

The computer salesman from Chattanooga, Tennessee is not alone in his initial feelings about contemporary art. Had he not had the opportunity and taken the initiative to learn more about it, he might have continued to believe that "anyone could paint like that." His experiences in the class at the Hunter Museum were an important influence in helping him to better understand painting and painters and stimulated him to open his mind to further exploration of art that he had initially found difficult to understand.

Visual arts institutions generally have more readily accepted the education of audiences as part of their responsibility than have the performing arts. Traditionally, American museums have seen their missions as collection and preservation, exhibition and education, but in recent years, the educational function has become even more important. In the 1960s, museums were under pressure from the public to appeal to a larger segment of the population. Across the country, they developed new learning programs and began to design exhibits that would reach a more diverse population. According to a 1985 report by the Commission on Museums for a New Century entitled *Museums for a New Century*, "In the turbulence of the late 1960s and early 1970s, museums were perceived as ivory towers outside the mainstream of society. Their traditional authority was challenged, their relevance to society challenged. In the struggle to respond, museums reaffirmed their commitment to a public role. Both physically and intellectually, museums became more accessible to more people."[1]

In order to change their image, they not only provided more exhibits that were more accessible and appealing to a broader public, but also began to provide more and better programs and materials for this new audience to help them learn about art forms as well as specific exhibitions. Yet many museum directors and directors of education believe they should do still more to extend their educational efforts beyond what they are now doing and to increase and improve their learning programs, especially for adults.

The commission issued 16 recommendations in its report to this country's museums about future directions. Four of the recommendations were concerned with the continuation and development of educational programs not only for children but for adults as well. One of these read: "Education

109

is a primary purpose of American museums. . . . We urge that museums continue to build on their success as centers of learning by providing high quality educational experiences for people of all ages, but in recognition of the increasing median age of our population, that they *pay new attention to their programs for adults*. [Emphasis added.]"[2]

According to *Museums for a New Century*, museums were founded and developed in this country with the "notion that they should communicate the essence of ideas, impart knowledge, encourage curiosity and promote esthetic sensibility."[3] The commission's conviction about the importance of museums as places for learning is strongly stated. "If collections are the heart of museums, what we have come to call education—the commitment to presenting objects and ideas in an informative and stimulating way—is the spirit."[4]

In their belief that they must continue to expand and improve the learning experiences they offer to their constituencies, the leaders of America's museums seem far ahead of the performing arts in taking seriously the "notion that they should communicate the essence of ideas, impart knowledge, encourage curiosity and promote esthetic sensibility" and that education should be the "spirit" of their institutions. While many performing arts organizations *have* created some imaginative learning programs for audiences, often these programs seem to be but a minor function of a volunteer organization, the marketing department or the literary division. They have not been conceived as integral to an institutional mission or an audience development philosophy, and during budget crises they are often the first programs to be cut.

There is the feeling on the part of many performing arts organizations that the educational programs they *do* occasionally offer don't really help in developing new audiences. The only people who seem to attend are the same, small group of faithful Yeses. It appears that the institution is "preaching to the converted." Though this may often be the case, we believe that learning programs *can* be conceived and executed more imaginatively to *appeal to the Maybe audience* and can be promoted more effectively to that group.

Learning experiences for arts audiences fall into two basic categories. One is the *specific event*-oriented kind of activity which relates directly to one production, performance, concert or exhibition or to related multiple events. The other is the *general* category of program which may deal with an art form itself; with a playwright, painter, composer, choreographer, poet, sculptor or musician; with a period, style, technique, school, medium; or perhaps with an idea, a contemporary issue or a philosophy. The most common kind of learning activity now offered on any regular basis is of the specific variety. Largely untapped are many opportunities for creative

110

programs of a general nature aimed at developing a greater understanding of art and artists and a more active curiosity and sense of adventure about participating as audience.

THE GENERAL CATEGORY
Participatory Programs—"Doing the Art"

The story of the computer salesman from Chattanooga serves well to spotlight a particularly important element in the process of helping people to open their minds to the arts in general and to discover their joy. It is an element too often overlooked in the design of learning activities for adult audiences: participation. Doing is as important as observing. Trying something is as illuminating as having it explained.

Eloquent testimony to the power of participation comes from a man who has devoted his life to arts education, Mark Schubart, for 25 years director of education for the Lincoln Center for the Performing Arts. In 1970, under a grant from the Carnegie Corporation, Schubart began a probing study which led to the restructuring of the center's education programs into the Lincoln Center Institute. A key component of the institute's activities is an intensive three-week summer session for classroom teachers, principals and occasionally some school superintendents and school board members.

The goal of the summer sessions is "two-layered," according to Schubart. "Obviously we want to give them something to take back to their schools to share with the kids," he says. "But in addition to being educators, *they are also adults*. And our first objective is their *own* development. We try to change the way they look at the aesthetic experience. To help them have a living, breathing, responsive reaction to art.

"Most teachers, like most adults, initially have an intellectual, historical approach to the arts. There are plenty of people who can quote Shakespeare, chapter and verse, but who have never really *felt* the power of his work as a total experience. It comes from our Puritanical heritage, I think."

The Lincoln Center Institute's summer session involves an intense combination of multi-disciplinary observation and participation. There are the experiences of watching rehearsals, attending performances and visiting museums, plus daily classes and workshops under direction of teams of artist-teachers representing the disciplines of music, theater, dance and visual arts. The activities range from theater games and dance exercises to drawing and sculpting to writing and presenting musical theater pieces.

"Without question the participatory elements of the summer sessions are at least as important as the observational aspects in helping people to

111

see the arts in a different way and to learn to be truly responsive to them," Schubart says. "When you try to *do* something, it helps you understand better what it's all about. It's like riding a bike. You don't know how hard it is until you try and suddenly realize there's nothing at all to hold you up."

Although participatory activities are fairly common in arts education programs for children, they have *not* been as frequently included in programs for adults. Normally, adult programs take the form of lectures and discussions from formal to ad hoc and reading materials from academic to superficial.

The integration of "doing" with watching and discussing is one of the most significant creative challenges in exploring and designing new ways for people to discover the joy of the arts. Though attended by educators, the summer sessions of the Lincoln Center Institute can serve as an important model for programs geared toward broader participation, since they are designed as much as anything for the aesthetic development of *adults*.

Discussion, Demonstration and Performance

One of the most successful programs designed to help people learn about the performing arts is Affiliate Artists, Inc. At the heart of this unique program is the belief that a performer can stimulate people's curiosity and interest in an art form by *sharing* informally, in conversation and demonstration, his or her feelings, skills and knowledge about being an artist.

The concept was born in 1966 when a howling blizzard prevented all but a few members of the audience from attending a recital by operatic baritone Ed Warner at Beloit College in Beloit, Wisconsin. Undaunted, Warner proceeded to entertain the small gathering with a potpourri of songs, demonstrations about music, comments about the role of the artist and anecdotes about his career. So enthusiastic was the response from his tiny audience that he was inspired to create the Affiliate Artists organization for the purpose of recruiting other singers and training them in the art of informal performance, later to be named the "Informance."

Initially, Affiliate Artists sent specially trained singers into communities for periods of residency totaling eight weeks in a year, sponsored by a local organization. The sponsor booked the performer for "Informances" in every conceivable kind of location and situation, from factories, Kiwanis Clubs and churches to school classrooms, public parks and hospital wards. The objective was to reach new audiences who would not normally be attracted to concert halls and to open their minds and their hearts to the possibilities of classical music. In almost every case, one or more formal performances

were presented toward the end of the residency periods in an attempt to bring some of the new audience into the more traditional concert hall environment.

Eventually the Affiliate Artists concept was expanded to include dancers and actors, instrumental soloists and conductors; and many variations have been played on the length and nature of the residency. But the basic concept of the performer helping people to understand more about artists and art through a combination of informal conversation, demonstration and performance is still the heart of the program. Affiliate Artists' success stories are legion, and there are many documented case histories of people who had never attended formal performances being motivated to attend by their experience of the Informance. No one connected with the Affiliate Artists program will ever forget the sight of a hundred or more workers standing transfixed in the heat, the hissing and the flickering redness of their Beloit, Wisconsin foundry, listening to soprano Mary Beth Piel sing the Mozart *Alleluia* to the accompaniment of Bunyan Webb's guitar.

Affiliate Artists' basic idea—taking an informal performance/demonstration to audiences of Maybes and Noes in surroundings which are comfortable for them—is one that could be applied by almost any kind of performing arts organization. Although not *every* performer is capable of making an entertaining and effective informal presentation, Richard Clark, president of Affiliate Artists, estimates that at least 75 percent of all artists have the potential. The key is careful preparation and training, and this requires a commitment of time and effort on the part of the arts organization and the participating artist. But the technique is so effective in helping people learn about artists and art forms that it would seem worthwhile for more organizations to explore the possibilities more seriously.

In performances that he calls *Keyboard Conversations*, pianist Jeffrey Siegel has created a format that entails his verbal interpretation and historical analysis of a musical piece which he discusses prior to performing the work. "I'm trying to make people better listeners," he says. "A person will get more from music if he or she knows more." In 1985 he presented *Keyboard Conversations* in 14 cities across the country.

THE SPECIFIC EVENT-ORIENTED CATEGORY _____

The most common kinds of learning programs focus on specific events. They include programs and materials provided *in advance* of performances or exhibitions and those that are offered *at the time and place* of an event. The aim is to stimulate interest in a production or exhibit and help people to understand it better. With some insight into the issues, context and

113

background of a production, audiences and potential audiences may begin to open themselves up to experiences that might otherwise feel strange and uncomfortable.

Season Previews

A program which the Tucson Symphony Orchestra has been developing since 1984 is geared toward helping current subscribers and other classical music fans learn more about the upcoming season's concerts. Called "A Tucson Sunday Morning," it takes its name from a radio show, "Saint Paul Sunday Morning," which is produced by Minnesota Public Radio and broadcast nationally. The radio host, William McGlaughlin, is also conductor of the Tucson Symphony.

"A Tucson Sunday Morning" is conceived as a preview of the orchestra's season, and subscribers to all of their series are invited to attend. The local public radio station, whose members are also invited, is a co-sponsor of the brunch-concert event. McGlaughlin and a small ensemble of musicians discuss the various pieces to be presented during the season and perform pieces of the music or other works which help illustrate a story or concept. In addition, actors perform dramatic readings of stories relevant to the music.

The event not only helps current classical series subscribers to understand more about the season's offerings, it also gives subscribers to the symphony's other series a "peek" into the main series' programming. Radio members, many of whom are *not* orchestra subscribers, are offered an opportunity to learn more about their city's orchestra and what it does, and those who accept the offer can increase their own enjoyment of symphonic music. In return, the symphony gets an opportunity to interest the subscribers of other series in trying the classics and to encourage radio listeners to become ticket buyers. And the radio station can encourage orchestra subscribers to become station members.

Printed Materials

Printed materials provided in advance of a performance or exhibition take a variety of forms. Most arts groups feel that their newsletter serves the purposes of informing audience members about the institution and of making them feel like "part of the family." But few newsletters provide the kind of in-depth information that significantly enhances the audience's understanding and appreciation of the programs the organization presents. Most contain little more than story synopses and "backstage gossip" and are often lacking in substantive, insightful, readable information.

114

But from time to time, a variety of performing arts organizations around the country have successfully utilized thoughtful, well-designed advance publications. In 1985, the Great Lakes Theater Festival in Cleveland, Ohio began publishing *Curtain Going Up!*, an attractive magazine with feature material on each of the company's productions which was mailed to subscribers in advance of the summer season. The Guthrie Theater's *Setting The Stage* was mailed to more than a half-million people in advance of each season during the company's early years, and with its enclosed order form the magazine functioned as a subscription brochure. But it was far more than just a promotion piece. Like *Curtain Going Up!*, *Setting The Stage* included a section devoted to each of the plays, which were examined from the unique perspectives of various directors, designers, authors and performers and within the context of theater history. Set and costume renderings, production photographs, historical materials and other visual aids illustrated the concepts and ideas discussed in the text.

Printed materials do not have to be costly. The Tucson Symphony Orchestra's *Overtures*, a small, inexpensive pamphlet, is mailed in advance of each classical concert to subscribers *and* to potential single-ticket buyers on the orchestra's mailing list. *Overtures* takes the place of a regular single-ticket promotion piece, but it is more about learning and understanding than selling. Each issue contains one or more short features relevant to the music being performed at the concert, based on interviews with the conductor. The text is informal, entertaining and informative, and often it is supplemented with "exercises" that readers can try at home on their own instruments.

In the early 1980s, the Guthrie Theater began mailing similar pamphlets to its entire mailing list prior to each production. These pieces generally featured an interview with one of the production's principal artists and other short, informative items. Because of mailing costs, the theater eventually stopped producing advance pamphlets for each show and began publishing the quarterly tabloid that is distributed at key locations throughout the area and mailed to subscribers.

Video/Audio Recordings

Many museums provide visitors with audio systems for self-guided tours. At the Museum of Modern Art in New York City, Director of Education Phillip Yenawine is exploring the possibility of producing video cassettes about special exhibitions or various aspects of the permanent collection. People planning a museum visit could borrow or rent the cassettes for use in their homes *in advance* of their coming. Yenawine believes that both video and audio recordings open up a new world of possibilities for

115

providing arts audiences with a variety of entertaining and effective learning experiences.

We believe that they could be just as valuable to the performing arts. Video and audio tapes could help people learn about specific productions or about an art form in general. Arts groups should explore the possibilities of producing the recordings in cooperation with public radio and television stations; public libraries might help with distribution.

Classes

Special classes can be offered to audiences and potential audiences through a local college or university, or they can be conducted internally, with the staff of the arts organization serving as instructors. The Krannert Center at the University of Illinois (Urbana-Champaign), through the school's continuing education department, regularly provides adult classes focusing on major programs to be presented by the center. For example, in conjunction with a kabuki-style production of *Medea*, a 12-week, three-hour course was offered. The production was directed by UI artist-in-residence Shozo Sato, who also taught the course.

Seminars / Workshops

One-shot lecture / demonstrations and workshops are often presented in advance of an arts event by less formal educational organizations such as public libraries or community centers, as well as by arts organizations themselves. Seminars offer in-depth explorations of a production-related subject or detailed, thought-provoking examinations of the career of one of the artists involved.

During the 1981-82 season, the Guthrie Theater presented *Eli: A Mystery Play* and *Eve of Retirement*, two plays which explored the holocaust from two different perspectives. To help prepare audiences for these productions, the theater presented a seminar, "Fascism and the Holocaust." The seminar included a slide presentation and dramatic readings by members of the company as well as a panel discussion featuring the directors of the two shows, rabbis and other community members knowledgeable about the subject. More than 900 people attended this September, Sunday-afternoon program, which was followed by a reception for the audience, panel members and actors.

At the University of Nebraska-Lincoln, a somewhat less traditional kind of seminar has been initiated in connection with the performance series *The World On Stage*. The "Saloon Seminars," as the name suggests, are held in a bar.

116

Faced with the challenge of attracting more students to the many, high-quality professional touring events sponsored by the university each year, the director of the series, Ron Bowlin, decided to experiment: he would offer an informal demonstration/performance program free of charge at McGuffey's Saloon, a favorite off-campus hangout. McGuffey's has a large, cabaret-style room with a stage where jazz is presented on Thursday nights. The ambiance seemed ideal.

For the first Saloon Seminar, Bowlin prevailed upon the performing duo of Richard Stoltzman (clarinet) and William Douglas (bassoon and piano) to come to Lincoln the day before their regularly scheduled appearance on the formal series. The event was promoted with flyers distributed across the campus, and on the appointed evening, a full-house of students showed up at McGuffey's for an entertaining two hours of talk and music by the personable Stoltzman and Douglas. The following morning, the several hundred tickets remaining for the evening concert were quickly sold to UNL students.

Several other Saloon Seminars featuring artists from the series have been successfully presented. One, for the touring production of the play *Foxfire*, made use of a local folklorist of national reputation when cast members could not arrange to be in Lincoln in advance of their performance. During the 1986-87 season, modern dance choreographer Merce Cunningham appeared in a Saloon Seminar.

Pre- and Post-Performance Discussions

Activities that happen *at the time and place* of an event are the second major category of learning programs. The most common are pre- and post-performance discussions, usually involving artists and members of the audience. Many theaters and some symphony orchestras offer discussions several times during the run of a production or series of concerts. They are less common with dance companies. Museums provide film and slide shows that can be viewed before touring an exhibit, tours with volunteer leaders, or audio cassettes for self-guided tours.

Unfortunately, pre- and post-performance discussions often are not carefully thought out in advance, and with inexperienced moderators, lively and productive discussions are difficult to generate. Lacking focus and structure, the talk wanders, and the experience becomes a dull one for audience and artists alike.

Only a *trained, experienced* moderator can stimulate an audience into asking questions, can skillfully rephrase questions when necessary, can channel each question to the appropriate artist. Moderators should *do their homework*. Possible topics should be explored ahead of time, and artists

117

should meet with the moderator to determine what they, as a team, want to accomplish with the audience and what each team member has to offer. Both moderator and artists must be committed to making the discussions as productive and interesting as possible.

The Royal Winnipeg Ballet in Canada has created a program called "Saturday Behind the Scenes." Before each of its Saturday matinees, an informal interview is conducted with one of the company members—a dancer, a guest choreographer, or even a crew member. The 20- to 30-minute program is held in a small concert hall and moderated by the communications director. After the interview, the program is opened to the audience for questions and discussion. According to the communications department, the program is popular, with 150 to 300 people attending each session.

Program Books

Program notes and features are obvious opportunities for communicating with audiences. However, many programs are either too technical or simply too dull to capture the imagination of general readers and help them better understand what they are about to see.

Frequently, the job of writing the pieces is given to a dramaturg, musicologist or historian. The audience-development director can depend on these people for expert guidance in choosing subject matter and as an invaluable resource in the preparation of material. But the needs of audiences are *not* necessarily best served by letting the experts write the articles. More often than not, they write for their peers or for a sophisticated audience of Yeses rather than for people who want to learn the basics about the art form or the production. To the new audience member, literary essays may seem dry and boring, or come off as esoteric pontifications. They can reinforce the idea that a person has to be very erudite in order to enjoy the performance. The novice is likely to think, "If I can't understand the program notes, how will I ever understand the performance?" or, "If the notes seem senseless, the performance will probably be pointless, too."

At the other extreme, one must be careful not to fall into the trap of "the music appreciation racket" by writing material that trivializes the subject. Always one must strive for the "happy medium."

Lobby Displays

Rarely are lobby displays used for anything other than photos of company members, guest stars or past productions or to promote upcoming events, subscription sales or boutique items. But the lobby can be an ideal

118

place for visual and printed materials that enhance the audience's understanding of current and future productions. Especially valuable are displays that help prepare audiences for future events that are somewhat more challenging than the one they are attending. Lobby displays should be designed to help audiences *learn* enough about the subject or the context of a future production to make them feel more comfortable about attending something that seems unfamiliar and strange.

The possibilities for developing entertaining and informative learning programs that strike the happy medium are limited only by the imagination and creativity of artists and their institutions. Many arts organizations have made promising beginnings, and yet it seems that they have barely scratched the surface. Beyond this is an even greater challenge, that of integrating learning programs with artistic experiences in a system of stepping stones that leads new audiences from a first sampling of an organization's wares toward full commitment to the institution's artistic mission.

HELPING THE MAYBES TO BE YESES

"I just don't understand why the kids can't see it when it comes on TV."

Mark and Mollie, while doing the dinner dishes, were discussing Christmas-time entertainment possibilities for their family.

"It's the same thing as the play, only it won't cost us any money."

In this case, Mark was referring to the Charles Dickens classic *A Christmas Carol*, which the B & J Repertory Theater Com-

pany was presenting for the holiday season. Mollie had seen an ad for the show in the Sunday paper and suggested that they take five-year-old Matt and eight-year-old Megan. Last year, she and Megan had enjoyed a performance of *The Nutcracker* and she now felt that Matt was old enough to be included.

"I don't know, Mollie. Five is pretty young for a kid to sit still for two hours inside a theater. Especially a boy like Matt." Mark loaded the last of the pans in the dishwasher and added the detergent. "You know, it's not like those outdoor pops concerts in the park where the kids can play if they get bored. If they get tired in a theater, we're just stuck." He closed the door and pushed the button. "It makes a lot more sense to me if they just watch it on TV."

They had already agreed that Matt and Megan would like to see the Christmas Trees Around the World exhibit at the local museum. But Mollie thought doing something else as a family would be fun.

"Bob Michaels down at work says *Christmas Carol* is really good." Mollie was an executive secretary for the largest law firm in the city, Mosher, Morten and Michaels. She often heard about the B & J Repertory Theater Company from her boss and occasionally wrote solicitation letters for the various arts groups in town when Michaels was helping them to raise money.

"He's been on their board of directors, you know, and he says he's sure Matt would enjoy it because the show is designed for the whole family." Mollie turned off the kitchen lights and followed Mark into the living room. "Besides, if you remember, both Megan and Matt were *fascinated* by that last outdoor pops concert. They sat right up near the front the whole time."

Mark loved the pops, partly because he could drink beer and let the kids wander when they got restless. But Mollie noticed he usually resisted more formal kinds of entertainment.

"I don't know, Mollie, plays like that are usually pretty expensive."

She picked up the Sunday paper and held the ad under his nose. "They have a special family rate. See, parents get in free when they go with their children."

Mark flipped on the television and collapsed in his favorite chair. "O.K., then you take the kids, and I'll stay home."

"Oh, now I get it!" She sat down cross-legged on the floor in front of him, blocking his view of the set. "*You're* the one who's afraid he'll be bored and won't be able to sit still for two hours."

"Come on, Mollie. It just seems like a waste of time when we can see it free on television. And besides, I'm not sure the play would be all that good."

She was steaming a bit, now. "As far as I know, the only play you ever went to was Carol what's-her-name in *Hello, Dolly*, and you liked that. So what makes you think you won't like this one?"

Mark sat up. "Well, I probably didn't tell you about it, but I saw a couple of those classical plays on field trips in high school, and they were really boring. So how do I know this won't be more of the same thing?"

She saw an opening. "Well, I used to think football was a pretty dumb game when I was in high school. Really boring. But since I've been going to the games with you, I understand more about it, and it seems more interesting." She paused to let that sink in. "So how about coming to *Christmas Carol* with us?"

Mark slumped back. "All right, Moll, but not on a football night, O.K.?"

In order to illustrate the Strategy to Encourage Lifelong Learning, we have created an imaginary family of Maybes who, over a period of ten years, become deeply involved with the life of a professional theater company. They are Mark and Mollie Maybe; the theater is named the B & J Repertory Theater Company; and they all live in Hometown USA.

It is not uncommon for Maybes such as Mark and Mollie to struggle over whether or not to attend their first performance, concert or exhibition with an arts organization that, to them, is an unknown quantity. In this hypothetical example, the Maybes will continue to be uncomfortable about unfamiliar experiences. It is the B & J Rep's job to try to understand the Maybes' concerns and to help them feel increasingly more at home in the theater.

The artistic mission of the B & J Repertory Theater is to present classic plays as well as contemporary plays of potential classic stature. Selections are packaged into three series representing different stages of adventure for a developing audience. They are the Discovery, Classics and New Adventures series. The packages are designed so that there is an overlap of one play between the Discovery and Classics and one between the Classics and New Adventures series. For example, if Chekhov's *The Three Sisters* is on the Classics series, it may also appear on the Discovery series. And if Beckett's *Waiting for Godot* is on the New Adventures, it may also appear on the Classics series. Thus, the overlap allows subscribers to one series a "peek" into the next.

Every year the B & J presents *A Christmas Carol*, which is a primary Point-of-Entry for new audiences. Usually, two other Points-of-Entry are

designated from the Discovery series each year. In a given season, the three series may look like the following:

Discovery	Classics	New Adventures
Our Town by Thornton Wilder	*As You Like It* by Shakespeare	*Mud* by Maria Irene Fornes
My Fair Lady by Lerner and Lowe	*Waiting for Godot* by Samuel Beckett	*Waiting for Godot* by Samuel Beckett
The Three Sisters by Anton Chekhov	*The Three Sisters* by Anton Chekhov	A New Commissioned Play
	Rozencrantz and Gildenstern are Dead by Tom Stoppard	
	Master Harold . . . and the Boys by Athol Fugard	
Special: *A Christmas Carol*		

The Theater Company also provides many learning programs and materials for its audience. Informal discussions, which B & J calls "curtain talks," are conducted after most Discovery performances. Prior to the Classics plays, the audience development director conducts special interviews with members of the cast, technicians, directors, administrators and community members to discuss various aspects of the theater in general or the specific production. And discussions, short seminars or workshops are made available to the audience prior to plays on the New Adventures series. For each of the Classics plays, the organization mails an eight-page booklet filled with interesting magazine-type features about the play. In early fall, the B & J produces a preview event of the plays in the upcoming season. A volunteer group coordinates fundraising events and schedules entertaining learning activities and special programs for its members.

The theater invests the most significant portion of its marketing budget in external communication for the sale of single tickets to Point-of-Entry events. For these the B & J spends 43 cents per dollar of income. Internal communication is much less expensive: the company spends only eight cents per dollar of income to renew subscribers, and all other sales are budgeted at 32 cents per dollar. Overall, the B & J spends 34 cents per dollar of income for audience development programs. (An explanation of Cost Per Dollar of Income is included in the appendix.)

The external communication dollars spent on Points-of-Entry are invested in print and radio advertising, promotions and a limited amount of

carefully targeted direct mail to outside lists. The sale of subscriptions and of single tickets to those productions not designated as Points-of-Entry is done primarily through direct mail to the organization's in-house list, supported by a *limited* amount of advertising.

The B & J has a staff of two for group and corporate sales. Their responsibility is to offer programs to civic and social groups and to develop sales to businesses. Trained volunteers present slide shows to civic and social groups to encourage their participation. The B & J also has a special Corporate Employee Program that is targeted at individual sales to business employees. B & J staff members work with a representative from each participating business; the rep encourages his or her fellow employees to "apply" for free membership cards entitling them to ticket discounts. The theater follows up by mail with a sales campaign targeted at the "corporate employee members."

When Mark and Mollie Maybe finally came to an agreement about attending *A Christmas Carol*, they were only at the beginning of their journey toward full commitment to the B & J Repertory Theater Company. But even then they were not completely naive about the arts. Not only did the family occasionally attend the pops concerts given by their city's symphony orchestra at the park bandshell, but they had also made a special trip to see the Vatican Treasures exhibit in Chicago and had visited the Smithsonian in Washington, D.C. Mollie had taken their eight-year-old daughter to *The Nutcracker* produced by the local ballet company, and she had attended several musical road shows, including *Hello, Dolly* with Mark.

But these were special occasions. The arts were not an integral part of their lives. This is the story of how, over a period of ten years, a family of Maybes became deeply involved in the life of an arts organization.

Year 1: Waiting in the Wings for the Point-of-Entry

At the performance of *A Christmas Carol* the Maybes find flyers in their programs about a drawing for four tickets to *My Fair Lady*, the spring musical. All four fill out their forms—name, address and phone number— in hopes that one of them will win the tickets. In the lobby, they spend time looking at a display about the Lerner and Lowe classic with vintage pictures of London, photographs of original cast members and information about the upcoming production.

The family, including Mark, agrees that *A Christmas Carol* was wonderful and better than watching it on TV. Mark suggests that they go to the B & J again some day.

Two months later, the Maybes receive a letter and brochure about *My Fair Lady*. They didn't win the four tickets, but the letter suggests they might enjoy going anyway. And they do.

Year 2: Reluctant about the Russians, But They Try Two More

In early September, the Maybes receive a B & J brochure about a series of three plays. The Discovery series includes *Our Town*, *West Side Story* and Chekhov's *The Three Sisters*. Mark doesn't think the Russian play sounds very entertaining but thinks he *might* enjoy the others. They decide to buy single tickets to those two shows.

At the first production, *Our Town*, they discover that some of the cast will talk with the audience following the performance. They stay and enjoy learning about the actors and some technical aspects of the theater. The "curtain talk" is moderated by one of the staff who carries a microphone into the audience. The moderator rephrases questions when needed and also directs queries of her own to the cast in order to generate others from the group. The Maybes decide to attend other curtain talks when they can.

In the spring they get a letter and brochure about subscribing to the Discovery series. They put the decision off for a couple of months until a volunteer from the theater calls to ask if they have considered purchasing the series as the letter suggested. Indeed, they have discussed it, but they have not made a decision. After talking with the volunteer about the plays they are unfamiliar with, the Maybes decide to try the series.

Year 3: The Maybes' First Year As Discovery Subscribers

The Maybes attend all three Discovery Series plays and two of the curtain talks. The renewal letter comes in March. The Maybes put off a decision until a volunteer calls to remind them about the deadline. Mark talks to the volunteer about the plays and how he enjoyed them, but he hasn't heard of two of the shows in the upcoming season. He asks what they are about. After the volunteer explains more about the plays, the Maybes decide to subscribe for another year.

Year 4: They Renew Discovery and Try a Classic

In the Maybes' mail during the fall comes a letter and brochure about a play on the Classics series, *A Streetcar Named Desire*. The letter contains a play synopsis and offers a 15-percent discount on tickets. Mark and Mollie remember seeing an interesting lobby display about *Streetcar* at the first production of the season. Mark's mother will be visiting during the *Streetcar* run and they could make a special evening of it. They decide to go. After the performance, Grandma Maybe says she's not too sure about the

126

WAITING IN THE WINGS

play, but the younger Maybes agree, privately, that they both enjoyed the story and the jazz score.

In the spring the Discovery renewal form arrives in the mail and within the week, the Maybes renew.

Year 5: The Maybes Try Shakespeare and Get Intrigued with the Classics

The Maybes attend the Discovery performances and, when possible, the curtain talks. They begin to receive a series of eight-page booklets with short features about the plays on the Classics series. Mark skims the first one or two and tosses them into the wastebasket, but eventually Mollie sits down to read a few issues and becomes interested. In mid-winter comes another letter with discount coupons, this time for a play on the Classics series, *Romeo and Juliet*. At one of the Discovery performances, they see a lobby display about *West Side Story* and *Romeo and Juliet*. They had seen *West Side Story* three years before and both had read the Shakespeare play in high school. But neither had ever *seen* a play by Shakespeare. Their daughter, Megan, has just turned 13, and they invite her to attend with them. The three Maybes see the Shakespeare classic, and although they don't understand all the language, they enjoy the production.

Toward the end of the season they receive an invitation to attend a preview of the next year's plays—a reception with desserts and coffee followed by a program. The B & J also suggests that the Maybes change their subscription to the Classics or add the Classics to their Discovery series.

Mark and Mollie feel they don't have time to attend all six Classics shows, but they attend the preview anyway. The volunteer group has helped plan and coordinate the event, and they have made the special desserts and provided a selection of coffees. The program, devised by the artistic director, centers on the theme, "Women in the Theater." The upcoming season will include *Toys in the Attic* by Lillian Hellman and Marsha Norman's *'night, Mother*, and two of the other plays will be directed by women. The B & J has also chosen women designers for the lighting, sets, sound and costumes for several of the plays.

The preview program opens with a mini-performance of a one-act by a woman playwright, followed by the artistic director narrating a series of slides on plays by and/or about women, and a historical look at actresses and women directors and designers. Eventually, a panel of community leaders and artists from other disciplines discuss the subject and open their discussion to the audience for questions and comments. Following the program, refreshments are served and the artistic company, staff, board mem-

127

bers and volunteers mingle with the audience, introducing themselves, learning as much as they can about the people who have chosen to attend the preview, and answering any questions these people may have about the B & J, its selection of plays, the volunteer group or any other aspect of the theater that may intrigue or puzzle them.

In the lobby, tables have been set up for renewing subscriptions and for soliciting new subscribers. The Maybes give their check for the Discovery series to a volunteer.

Year 6: The Year They Decide to Subscribe to the Classics

The Maybes attend their Discovery series plays and the curtain talks, and during the winter, the theater and museum co-sponsor a program featuring a museum tour, a workshop and a reception. Mark and Mollie decide to attend with 10-year-old Matt. The museum tours are led by an actor, a musician and a dancer, each of whom interprets the works of art as he or she sees them. The group then participates in a workshop for children and adults on how people see the same thing in different ways—just as the three different kinds of artists saw the same piece of art in different ways.

In the spring, the Maybes receive another invitation to the season preview and another letter suggesting that they try the Classics. Mark and Mollie attend the preview and discuss the plays on the Classics series with the board chairman and with a member of the volunteer group. All of the plays—Discovery *and* Classics—sound interesting, but the Maybes don't have enough time for both series. Still, they would like to attend the theater more often. They have enjoyed all the Classics plays they've seen with their Discovery subscription, as well as the Shakespeare for which they purchased single tickets, and they enjoy the material they get in the mail.

A week after the preview, they change their season tickets to the Classics.

Year 7: The Maybes Continue Attending the Classics

The booklets continue to come in the mail for all the Classics programs. The Maybes attend a panel discussion and film about South Africa the week before the opening of Athol Fugard's *Master Harold . . . and the Boys*. For the other plays, they attend pre- or post-production "interviews" with members of the company and guests from the community.

They enjoy most of the Classics productions, and at the end of the season, they attend the preview once more and renew their Classics series subscriptions.

Year 8: They Join the B & J Volunteers

The Maybes get involved with the B & J volunteers after a member of the group calls to tell them about their activities and ask if they would be interested in participating. The Maybes attend their first meeting at the home of the group's president. After the business of organizing the fall fundraising event is completed, a designer gives a talk about the costumes for a play on the Classics series and does a demonstration on mask-making for them. The Maybes learn that all the meetings of the volunteer group include some kind of program about the plays from the various series or about theater in general. The meetings are held in a home, at a restaurant or the theater. Sometimes the programs are participatory, others feature a guest speaker, and occasionally there is a mini-performance and discussion.

With their children getting older and more independent, Mark and Mollie think they will have enough time to work with the group. Although they don't get to all the activities, they do attend more than half of them. And in addition to attending all of the Classics shows and some of the pre-performance discussions, they assist in the subscription campaign and in a fundraising event. In the spring, the Maybes renew their Classics subscriptions.

Year 9: The Year They Contribute Money and Become More Adventurous

The Maybes begin to get more deeply involved with the volunteer group. One of its programs is about a new play on the New Adventures series. A special performance, followed by a program afterward and a reception, is presented just for the volunteers. It's a strange play, the Maybes agree, but they are pleased that the theater provided the discussions before and after the performance so that they could have some "clues" about what was going on. At the end of the season, they renew their season tickets and contribute to the annual fund drive as well as work on the major spring fundraising event.

Year 10: And Finally, a Full Commitment

A major workshop is presented about two plays. One, *Galileo* by Bertolt Brecht, is on the Classics series, and the other, a new play about Albert Einstein, is on the New Adventures series. The Maybes were already planning to see *Galileo* on their Classics subscriptions. After the workshop, they decide to buy tickets to the Einstein play.

129

They become more active on the volunteer committee; Mollie is elected vice president in charge of programs, and Mark chairs the spring fund drive. They increase their own contribution by 50 percent.

After renewing the Classics, they attend a reception, and the artistic director of the theater talks privately with them about the New Adventures series. The Maybes tell her that they didn't really understand the New Adventures plays they've seen so far and don't think they want to add two more plays to their already busy schedule. But the artistic director's descriptions of the new plays she's considering for the series are intriguing. A couple of weeks later the Maybes receive literature in the mail about the New Adventures series and a letter suggesting that they add it to their Classics. "It's only about $30 more for both of us," Mollie says. "Let's go ahead and try it." And they do.

The following year the Maybes attend all the productions on the Classics and New Adventures series. They concur that the new plays don't seem as strange as did those which they sampled during the previous season. Mollie is elected president of the volunteer group, and Mark is asked by the board of directors to work on the annual fund drive. They continue gradually to increase their contribution, and they attend as many learning programs and activities as possible.

Over a ten-year period, the Maybes have become Yeses.

The B & J Repertory Theater Company management knows that not all their Maybes will become Yeses. Some will move through the process at a quicker pace than Mark and Mollie; some will skip over certain aspects of the process; some will never move beyond the Discovery-type productions. But everyone has the opportunity to participate in the lifelong learning process developed by B & J.

SELL need not be limited to larger institutions. Our B & J Repertory Theater Company produces three different series which serve as stepping stones in the audience's journey toward full commitment. For smaller groups, the stepping stones may be various levels of "membership" or smaller packages. There may be only one step in the Intermediate Stage of Commitment—a season subscription—with joining the volunteers and contributing money constituting the next and final stage of commitment.

Many arts organizations have developed imaginative and effective learning programs, events and activities for their audiences. Some have begun to offer packages of events that appeal to specific groups of people with common interests and similar levels of understanding in the art form. But few have fully integrated these programs into a step-by-step system. And it is our belief that this is essential. There can be no single formula for a strategy that will work for all arts organizations. Each must create its own to reflect its artists and their visions, its community and their needs and concerns. There *are* a few arts organizations that have purposely created

130

FIGURE 2: Mark and Mollie Maybe Discover the B & J Repertory Theater Company

YEAR 1

Notice ads and publicity in newspaper/radio about Christmas Carol. Attend. Name captured in drawing. See display about *My Fair Lady*. Receive letter about *My Fair Lady*. Attend.

YEAR 2

Receive Discovery series brochure. Only interested in two plays and they attend *Our Town* and *West Side Story*. Stay for *Our Town* curtain talk. Receive brochures about Discovery. Receive phone call. Buy series.

YEAR 3

Attend all Discovery productions and two curtain talks. Renew after procrastination.

YEAR 4

Receive brochure about and discount offer for *Streetcar Named Desire*. See lobby display about *Streetcar* at Discovery performance. Attend and enjoy. Renew Discovery.

YEAR 5

Attend all Discovery performances. Receive booklets about each Classics play. Receive letter about *Romeo and Juliet* with discount coupons. Attend with daughter. Receive invitation to Preview of next season. Attend. Renew Discovery at Preview.

YEAR 6

Attend museum tour and workshop co-sponsored by other arts groups. Attend the season preview in the spring. Drop Discovery tickets in exchange for Classics.

YEAR 7

Go to panel discussion about South Africa re: Fugard play. Attend pre-production discussions and read Classics booklets. Attend preview and renew Classics.

YEAR 8

Join volunteer group and become active. Attend all Classics and in spring renew subscriptions.

YEAR 9

Continue volunteer activities. Work on fund raiser. Program presented at volunteer's meeting about new play on New Adventures series. Attend the new play. At end of season, renew Classics subscriptions and give to annual fund drive.

YEAR 10

Attend workshop on plays on Classics and New Adventure series. Attend the play on New Adventures. Continue volunteer activity and increase contribution by 50 percent. Renew Classics and add New Adventures.

131

systems resembling SELL and others that have fallen into this approach almost by accident. Examples of both can be found in the appendix.

In the 1980s, cultivating a larger, more diversified audience is a challenging and demanding task. It requires nothing less than a complete reassessment of goals and a reordering of priorities. It also requires a new kind of patience. And the reawakening of an old kind of passion.

TOWARD A NEW PATIENCE AND AN OLD PASSION

"I have been in over 200 plays, played every state in the United States, made films, commercials and been on TV. And I still have the worst case of stage fright of anyone I know. And now I'm scared to death of you."

She glanced at the 45 men dressed in dirty coveralls standing around a dingy, chairless cafeteria. They were stony-faced. She took a deep breath.

"My name is Kathleen Gaffney and I'm a professional actress.

For the next 45 minutes, I'd like to tell and show you something about how I earn my living."

It was 3:30 p.m. on a bleak but warm February day in 1985. The shift was changing at the Early Times Distillery in Louisville, Kentucky, and these workers had stopped by—mostly out of curiosity, Kathleen guessed—to find out what an Affiliate Artist was and maybe just to see what an actress looked like, since it turned out that none of them had ever been to the theater.

There was no change on the faces as she launched into her "Informance," the name given by the Affiliate Artists organization to the informal, informative performances presented by its artists during community residencies. Gaffney was at the midpoint in a two-and-one-half week visit to Louisville sponsored by General Electric.

"Now I'd like to do a monologue from a play called *Talking With* that was first presented here in Louisville at your own Actor's Theatre. It's the story of a woman who loses her job with the rodeo because she's not pretty enough."

With movement and gesture alone, Gaffney turned herself into a cowgirl and began. And the expressions on those stony faces began to change. She sensed she was communicating. They were reacting because she was dealing with something close to each of them—having a job and being afraid of losing it. It was working!

Gaffney had been doing Affiliate Artists residencies for three years, though her background and experience were in classical theater. But acting one summer at a theater near Plattsburgh, New York, she was asked to perform several times at Danemmora Prison, and she became intrigued with working in nontraditional places. Later, playing Lady Macbeth at the Stratford (Connecticut) Shakespeare Festival, she started doing post-performance discussions with the audience and found that she loved the discussions as much as the shows. "Live theater is like playing a duet with your audience," she says, "and when they feel like they know you, they understand your work in a different way."

A television camera crew interrupted Gaffney's Informance at the Early Times Distillery. While the cameras rolled, she brought her audience into the picture, asking them questions and getting their comments. "Suddenly they became a part of the show," she recalls, "and magic started to happen."

An actress friend had introduced her to Sushi and Affiliate Artists on the very same, crystal-clear September day in 1981, at a

Japanese restaurant on West 45th Street in New York City. Eventually she came to love them both; and for Affiliate Artists, she did residencies in Georgia, Alabama and Wyoming before coming to Kentucky. With each Affiliate Artists experience came a more passionate commitment to reach out to more people.

"I want to *grow* more audiences for myself and all the other performers in the world and get closer to them," she told a friend one day. When her friend asked how she did that, Gaffney replied: "You find little seeds. And you plant them in the soil with that first contact. Then you water them. And nurture them. And help them grow to maturity!"

The attention was rapt now, as Gaffney reached the end of her Informance. "And so, here is what I have found out by doing what I do," she said. "I have found the truth of why I am afraid. And I have found the truth of what the philosopher Kierkegaard said: 'That which does not kill us, makes us strong.' Thank you for having me here."

The first clapping was tentative; then came a burst of applause. The workers at Early Times clustered around Kathleen Gaffney to thank her and wish her well. And to try to give back something of what she had been able to give to them. One brought a bottle of their very best bourbon for her to take home. Another gave her a set of Early Times drinking glasses. "Wait right here," said a third. "I've got something for you in my locker."

She talked for a while with a group of workers while a solitary figure waited in the background. The man who had gone to his locker returned with a slightly soiled, blue bandana that he thought would look nice on the actress. He and the rest of the group said goodbye and drifted off. The one in the background came forward.

"I never went to any theater before," he said, "but now I've decided I want to go to this Actor's Theatre in Louisville you mentioned. Can you tell me what I should see there and what I should do to go?"

She smiled a big smile inside. She had planted another seed.

As long as there are still artists like Kathleen Gaffney, with the same kind of boundless zeal for sharing their art that drove the Robert Joffreys and Gerald Arpinos before them, there will be the possibility that America can continue its journey onward toward cultural democracy. Without the artist's fierce dedication to excellence and unquenchable zest for reaching out, there is no hope. But artists cannot go it alone. Those who govern, manage and provide support to the institutions professing to serve art and

135

artists must recapture their sensitivity to the real reasons for the existence of the arts; they must demonstrate an unyielding commitment to the pursuit of those goals.

To us, most of America's arts institutions have reached or are reaching a major turning point in their journey from the periphery toward the center of society. They have a choice to make, and it is a clear one.

They can choose to maintain the status quo, to refrain from "rocking the boat." They can opt simply to continue serving a relatively small and stable audience of Yeses, composed primarily of affluent, well-educated, professionals and managers, while remaining more or less precariously balanced atop a carefully crafted mix of earned income, government, corporate and foundation grants and individual donations. This is the safer choice.

The other is to reaffirm their commitment to the conviction of the 1965 Rockefeller Panel: "the arts are not for the privileged few but for the many...their place is not at the periphery of society but at its center....They are not just a form of recreation but are of central importance to our well-being and happiness." Living up to that conviction will require the application of energy, imagination and significant resources to exploring new directions in audience development. These new directions must be capable of reaching beyond the Yeses to touch the lives of a new breed of audience who are intimidated by art or don't feel they know enough about it to enjoy it. This is the more difficult choice—by far.

We believe it is a viable choice. But there are risks along the way, and no institution should embark on the journey unless it understands and accepts them, unless it knows that the journey is a long and arduous one that requires a new kind of patience and an old kind of passion.

The new breed of audience waiting in the wings will not come quickly to center stage. They must be coaxed and nurtured. Patiently.

They do not represent a potential quick-fix for financial woes. The Strategy to Encourage Lifelong Learning (SELL) system cannot be introduced overnight like a new ad campaign for soda pop, denture adhesive or laundry detergent. With imagination and artistic sensitivity, it must be developed and honed through the years to match the character of the institution to that of the community. This must be done patiently.

Unlike those television commercial blitzes that can set soap sales soaring on next week's charts, SELL will not produce immediate, measurable results at the box office. Nor will it produce the "astonishing" sales that Danny Newman's DSP did in the initial years after its introduction. On the contrary, SELL requires substantial investments *now* that may not "pay off" in major ticket-sales increases for years, that may *never* yield full return except in the immeasurable currency of spiritual enrichment for new audiences. The organization must find satisfaction in slow, steady progress. SELL requires a *new kind of patience* based on the understanding that success in

136

reaching new audiences depends upon learning, and learning depends upon time.

The new concepts in audience development that we suggest need not be introduced all at once. In fact, even if it were possible, a sudden change of direction would not be desirable because of the unnecessary financial pressures such action might cause. The implementation of SELL must be evolutionary rather than revolutionary, built upon a series of small steps taken as creative ideas and new resources are developed. Patiently.

It is *critical*, however, that the artistic, managerial and lay leadership of the institution commit themselves wholeheartedly to the philosophy of this new approach and stick with it over the long term. Patiently.

The precise sequence by which new techniques and programs are implemented will depend upon the specific needs and characteristics of the particular institution and its community. But there are certain key steps that must be taken in the early stages of the evolutionary process. Here are some of them:

• **Capture Names and Develop Mailing Lists.** The development and maintenance of an efficient, all-encompassing list of names, addresses and phone numbers of all those whose lives have been touched by an institution is *crucial* to the success of SELL. An immediate and adequate investment must be made in the most thorough and efficient system the organization can afford for capturing names, keeping a history of each person's participation and making the names readily available.

• **Create Primary Learning Materials.** Develop a basic concept for utilizing the full mailing list to help all members of the institutional family *learn* more about the organization's programs and events. Typically, this will take the form of some kind of publication about one or more events that can serve the *function* of single-ticket promotion, but this must be done through lively and solid background information.

• **Develop Points-of-Entry Promotions.** Begin designating certain events in each season as Points-of-Entry. Focus external marketing resources and imaginative promotion techniques on single-ticket sales to new audiences at Points-of-Entry in order to extend the reach of the organization.

• **Explore Packaging Variations to Provide Stepping Stones.** Begin to develop a complete system of "stepping stones" so that new audiences, after arriving at the Point-of-Entry, can continue to learn and grow. Experiment with variations on season-ticket packages or memberships to create different degrees or stages of commitment for developing audiences.

• **Develop or Expand Other Learning Activities for the System.** Begin to create learning programs and activities beyond the primary printed materials and fit them into the stepping-stone process at various stages along the way. The nature and content of these programs should reflect active efforts to learn about the community, its concerns and its needs.

137

These are first steps. The evolutionary development of an exciting, imaginative and effective Strategy to Encourage Lifelong Learning will be accomplished only through a long-term, creative partnership between artists, managers, audience developers and trustees. The goals must be taken seriously. They must be pursued with the same imagination and fierce dedication to excellence that marks the pursuit of artistic goals. The search for Leonard Bernstein's happy medium between boring, esoteric technical discussion and the hype of the "music appreciation racket" must never stop.

This, and all other goals of SELL, must be approached with a new kind of patience. And perhaps even more important, there must be a reawakening of an old kind of passion.

The artistic visionaries of the 1950s and 1960s were evangelists. They *believed* that their mission was to respect, revere, love, nurture and develop audiences across a continent. The managers and community leaders who made it possible for the mid-century visionaries to accomplish an unprecedented expansion of culture throughout the nation *believed* that the arts were not just for the privileged few, but for the many, and that the country's challenge for the twentieth century was the achievement of cultural democracy. The artistic dreamers and doers of today like actress Kathleen Gaffney, *believe* it is their mission to "grow new audiences by planting little seeds," to water them and nurture them to maturity. They all *believe*. Passionately.

But the crusading zeal to reach out seems to stifle in the institutional milieu of today's politicized arts, where the key words often appear to be stability, status quo and survival rather than artistry, integrity and audience. Adapting the ends to fit the means is frequently seen as an easier, more practical solution than adjusting the means to serve the ends. A "passion" for seeking earned income has replaced the passion for sharing art. And the possibility of a true cultural democracy seems more remote than ever.

Remote but not vanished.

Reaching and nurturing the next wave of Maybe audiences is more difficult than motivating the initial base of Yeses. It will take more time, more imagination, more energy and often more money.

Raising ticket prices to keep the budget balanced may not discourage the faithful Yeses, but it will certainly not encourage the reluctant Maybes. And charging the Maybes for learning activities about the arts that they aren't sure they want or need is certainly self-defeating. Still, somebody has to pay the extra costs of reaching this new audience.

Some organizations can finance new programs by reallocating present resources; but for most, moving ahead will simply cost more. More money will have to be raised in contributed funds by managers and trustees committed to making SELL work. Passionately.

138

No arts institution is required to believe in cultural democracy. Maintaining the status quo is neither illegal nor immoral. But if the system isn't changed, the audience won't change. The institution may be able to increase earned income through products and activities a bit beyond the context of its normal programs. But it will *not* be able to bring substantial numbers of new people into its world and touch their lives with the integrity of its original artistic vision. That can only be accomplished if artists, managers, trustees and patrons acknowledge that it is inappropriate to change the product to make it sell better to the people; they must help the people understand the product. They must *believe* that is their mission. Passionately.

We believe that the arts in America can move ahead again in developing a larger and more democratic audience. We believe that the audience is there, waiting in the wings. We believe that the potential to reach it lies in the creative exploration of, and expansion on, the ideas we have set forth in this book. We do *not* believe that we have provided answers; we have only pointed out some new directions that might lead to answers. We believe that the arts should pursue these directions—with energy, imagination and dedication—and that they should renew their commitment to cultural democracy. We believe all of this. Passionately.

Art does not exist to serve practical purposes. It is misguided to try to justify its support on the basis of community prestige, economic impact, urban development, corporate image, enlightened self-interest or even the chamber of commerce quality-of-life. We must accept art as art, as an end in itself, and strive to make it part of the lives of all because, quite simply, it *is* the essence of civilization.

EPILOGUE

Driving north on Idaho Highway 75 through the rugged serenity of the Sawtooth Mountains, the traveler gradually climbs the great Phantom Hill and snakes through the pass at Galena Summit. Over the top, the road descends into a canyon which widens gently to a glorious valley. This day, the valley looks lush in the dappled light of a summer sun. The road meanders onward, and patches of wet meadows materialize here and there, the grass weaving gracefully and restlessly in the morning breeze. It is said that these meadows are among the very few mating and nesting grounds in all of North America for the Greater Sandhill Cranes, which arrive here in the spring from their winter habitat on the Colorado River of Arizona.

Some of the meadows are natural; some were created by early home-steaders and ranchers, plowing up sagebrush, planting new grasses and setting them to growing with irrigated water. So the wet meadows grew in size, providing new forage for settlers' livestock. But the new meadows they planted had effects far beyond the jagged peaks of the Sawtooth. For as the size and number of meadows grew, the biologists say, so did the world population of the Greater Sandhill Crane.

Hearing the story of Sawtooth Valley meadows and the Greater Sandhill Cranes inspires wonder in the traveler at the ways of nature and the delicate balance it strikes in the miraculous interdependence of each of its parts. Wonder that man's seemingly insignificant modification of his environment in the Sawtooth Valley could positively affect the worldwide population of a species of rare and endangered wildlife.

To someone fascinated with the life of the arts in America, it also sets the mind to exploring the possibility of a parallel between the sensitive, subtle eco-systems of nature and some unknown ways in which artists and audiences relate to one another in particular places.

Could it be that every city has some sort of eco-system of the arts—a delicate interrelationship of artists and audience? Could it be that the system by which members of an audience increase their involvement *within* a certain arts institution as described in this book may have some parallel but unplanned counterpart in the life of all the arts in a city or region? Is it possible that in every community there is some unstructured, natural con-

tinuum by which audience members move from one stage of involvement with the arts to another, more intense one, with artists and arts organizations interrelated and dependent upon one another without realizing it or consciously trying to be a part of the continuum? Could it be that if the arts *understood* the system of interrelationships they might modify it for the good of all, through cooperative action?

The idea seems worthy of eventual exploration, as a phase in audience development *beyond* the evolution of the Strategy to Encourage Lifelong Learning *within* institutions, a future phase which would embrace a strategy for all the arts in the community.

A system of interrelationships and interdependence may simply *exist* in any given place, as it does in nature. Man can modify his natural environment for good or for bad; but in order to know what the results of his actions may be, he must first understand the system as it stands. The same is true with the possible system of arts ecology as it exists in any given community.

In nature, any given place has a certain eco-system. The system has two kinds of components. There are the *biotic components* or living things, the plant and animal life. And there are the *abiotic components* or nonliving things, minerals and basic inert materials. There are very simple and very complex living and nonliving things. Together they achieve a balanced system in which each part is dependent in some way upon another. The simplest bacteria plays a crucial role in the life of other, infinitely more complex forms of life by "fixing" or releasing nitrogen, without which the higher forms would die. No single part of the eco-system can be altered without changing the whole.

In the cultural life of any given community, it seems probable that there is a similar kind of interdependence. An eco-system of arts, artists and audiences in which there is a natural, largely unplanned, unnoticed and un-understood interrelationship of one component to another, with the simplest and seemingly least sophisticated elements playing a crucial role in the life of those thought to be more complex and more "significant."

In every community, for the arts as a whole there probably exist several basic Points-of-Entry where new people are first introduced to cultural experiences. These general Points-of-Entry are probably fairly "simple" elements in the arts eco-system—artists and arts organizations that offer the kinds of programs which are the most aesthetically, psychologically and geographically accessible to the uninitiated and therefore the least intimidating. They are the places in a community where the most people get their first exposure to the arts.

If people feel comfortable at a Point-of-Entry, they may eventually become more adventurous and move on to some other kind of event within

that particular institution. If the institution *assists* in the process, through the kind of organized system we suggest, then the move will be made more quickly, more consistently and with a greater measure of commitment than if left to chance.

But there is *another* kind of growth, or change, in arts involvement that occurs in the life of many members of the audience: movement *beyond* the institution which has served as the Point-of-Entry. This may come about because of increasing curiosity about other kinds of activities and events *within* the same discipline. Or the movement may be from one discipline to another, motivated in all probability by experiences at the Point-of-Entry institution.

In any given community, this movement toward greater involvement with the arts beyond the Point-of-Entry institution is left almost entirely to chance. But we believe there may be some kind of natural, unnoticed, unplanned and imperfect system by which many members of the audience tend to move and grow in their involvement with the arts in general. Cooperative efforts to make the natural arts eco-system function more effectively can enable cultural organizations to reach more successfully into the audience of Maybes and Noes and to hasten the movement of the arts from the periphery toward the center of society.

Such efforts might take the form of learning activities or series of events which *cross* disciplinary lines to stimulate an audience's curiosity about other art forms and to help them gain the understanding that will make a variety of arts experiences accessible to them. Certainly, arts organizations should take into account and bring into the creative process the public radio and television stations. Joint learning activities might also include special performances, productions or exhibitions mounted cooperatively to provide stepping stones for audience growth where intimidating voids now block the path of progress. They might include programs which stimulate imagination and creativity and help people to feel less threatened by experiences that challenge their values and ideas.

The greatest deterrent to cooperative undertakings is likely to be the fear, on the part of specific arts organizations, of concepts that might *stimulate* the movement of their own audience toward other institutions. The fear of losing audience to other disciplines or to other institutions is an understandable one when the current pressure is so great to increase earned income. But some such audience movement will occur naturally, and it is unrealistic for an organization to think that it can hang onto all the people in its audience indefinitely, particularly if they are curious and sensitive people.

It is also important to recognize that if the whole system is made to function more effectively, then more new people from among the Maybes and Noes will be attracted at the community's Points-of-Entry, and more

143

people will be emerging at the more sophisticated end of the system, ready and eager to support a greater variety of more adventurous work. The total cultural life of the community will be vastly enriched, and the artists within it will have more opportunities to stretch themselves and push back the frontiers of their art.

It is difficult, to be sure, for artists and arts institutions still struggling to survive, still barely hanging on from crisis to crisis, still pressured to push up earned income no matter what the cost—or even for those finally enjoying a hard-won sense of stability—to give much concern to the tasks of enriching the total cultural life of their community and pushing back the frontiers of their art. But if they are not concerned, who will be? If they do not pay attention and do not act imaginatively and creatively in pursuit of their dreams, then who is to do it? If the artists and arts institutions among us are not the visionaries who will lead the way in the pursuit of richer and more meaningful lives for more and more people in our society, then who will lead us? In all probability, no one. It will simply be a matter of the survival of the status quo. And to us that is not enough.

To us, both the beachcombers who occupy the world between commerce and the arts and the artists themselves have a responsibility to be eternally *dissatisfied* with the status quo, to continue always in pursuit of something beyond what exists. And this is also a responsibility to *lead* the communities they serve, to enable their audiences to understand and support and join the pursuit of dreams.

The achievement of cultural democracy is a big vision. It will not be achieved by any individual artist or arts institution. It can only happen by acknowledging and understanding and cherishing the interdependence and interreliance of artists and arts organizations and audiences and communities, much as all of nature and all the parts of its ecological systems are inexorably and beautifully intertwined.

As we move ahead on the next leg of our journey, perhaps it will be helpful from time to time to recall the story of the Greater Sandhill Crane in the Valley of the Sawtooth Mountains of Idaho and remember how much it can matter when we plant a little meadow in our own backyard.

144

APPENDIX

REACH AND FREQUENCY: HOW TO CALCULATE AND USE THEM

The concepts of "reach" and "frequency" introduced in Chapter 6 are accurate and useful measures of audience size and trends. Together they provide a much more realistic picture than attendance figures of how well a community or institution is doing in touching the lives of the people it is trying to serve.

Reach for a whole community is the total number of *different* people who attend one or more arts activities or events in a given year. Similarly, for a specific arts organization, it is the total number of *different* people who attend one or more of the institution's programs, performances, exhibitions or other activities in a 12-month period.

Dividing the Reach by the population of the community's market area produces a *Reach Percentage*, the proportion of the market whose lives are being touched. Reach Percentage allows comparisons between different communities and between arts organizations.

$$\frac{\text{Reach}}{\text{Population}} = \text{Reach Percentage}$$

Frequency is the *average number of times* that people included in the Reach *participate* in arts activities of the community or the events of an arts organization in a specific year.

The relationship between Reach, Frequency and Attendance is simple:

$$\text{Reach x Frequency} = \text{Total Attendance}$$

With this kind of relationship, Reach and Frequency can be changing while Total Attendance remains the same; or Reach might remain stable while Total Attendance is going up, if frequency increases. A simple,

hypothetical example illustrates the implications of this relationship and why it is important to calculate and use Reach and Frequency.

The B & J Symphony in Hometown USA (population 250,000), plays ten concerts each year in a 1,500-seat hall. Every concert is completely sold out and total attendance for the season is 15,000.

There are two possible extremes for what the 15,000 figure may represent in terms of how many lives the B & J Symphony is touching or "reaching" each year.

Sold-Out To Subscribers

The B & J Symphony has 1,500 season-ticket holders, each of whom attends all ten concerts. The Frequency of attendance is therefore 10.0 and the Reach is obvious:

$$\text{Reach} = \frac{15,000 \text{ Total Attendance}}{10.0 \text{ Frequency}} = 1,500$$

$$\text{Reach Percentage} = \frac{1,500 \text{ Reach}}{250,000 \text{ Population}} = 0.6\%$$

Under these circumstances, the B & J Symphony is touching the lives of six-tenths of one percent of the people in Hometown USA.

No Subscribers And One-Shot Attenders Only

The B & J Symphony doesn't sell subscriptions, and nobody in the audience comes to more than one concert; but the Total Attendance for the season is still 15,000. The Frequency of attendance is therefore 1.0 and the formula produces the following reach:

$$\text{Reach} = \frac{15,000 \text{ Total Attendance}}{1.0 \text{ Frequency}} = 15,000$$

$$\text{Reach Percentage} = \frac{15,000 \text{ Reach}}{250,000 \text{ Population}} = 6.0\%$$

In this case, the B & J Symphony is touching the lives of six percent of the population or *10 times as many* as in the case of the other extreme, although the Total Attendance is exactly the same.

146

These examples begin to give an indication of how deceptive it can be to measure audience by Total Attendance alone, because it simply does not indicate how many lives are being touched. And Total Attendance does not necessarily indicate whether that number is growing, diminishing or staying the same. It is possible, for example, to have Total Attendance *increasing* while Reach is decreasing, if a diminishing group of people is attending more and more events each season.

The B & J Symphony decides it wants to begin determining Reach and Frequency each year so the staff can assess the institution's real service to the community and analyze trends more accurately.

During the current season they have 800 subscribers, each of whom attends all ten concerts. Under these circumstances, the following figures result:

800	Subscriber Reach
× 10.0	Subscriber Frequency
8,000	Subscriber Attendance
15,000	Total Attendance
− 8,000	Subscriber Attendance
7,000	Single-Ticket Attendance

In order to calculate *Total Reach*, it is necessary for the B & J Symphony to determine Single-Ticket Reach—how many different people are attending one or more concerts on single tickets.

Once the Single-Ticket Attendance is known, all that is necessary to calculate Reach is to determine the Frequency of single-ticket audience members.

At the last two concerts of the season, the B & J Symphony inserts a simple questionnaire in every fourth program. It lists the programs for all ten concerts for the season an asks the respondent to check all of those they have attended (or plan to attend). The survey also has a place to check whether the respondent is a season subscriber or a single-ticket buyer, and it asks a few other questions.

When the season is over, the questionnaires are sorted by whether the respondents are subscribers or single-ticket buyers. There are 140 questionnaires which were returned by single-ticket buyers. The number of concerts attended by those 140 people is added up and totals 378. Calculating Single-Ticket Frequency is then simple:

$$\text{Single-Ticket Frequency} = \frac{378 \text{ concerts}}{140 \text{ people}} = 2.7$$

147

With the Single-Ticket Attendance and Frequency known, the Reach can be calculated:

$$\text{Single-Ticket Reach} = \frac{7,000 \text{ Attendance}}{2.7 \text{ Frequency}} = 2,592$$

The Total Reach for the B & J Symphony's season then becomes:

$$
\begin{array}{rl}
800 & \text{Season Ticket Reach} \\
+\,2,592 & \text{Single Ticket Reach} \\
\hline
3,392 & \text{Total Reach}
\end{array}
$$

$$\text{Reach Percentage} = \frac{3,392}{250,000 \text{ Population}} = 1.3\%$$

The key to calculating Reach is to determine Frequency. This requires research, but generally of a fairly simple nature. Probably the easiest and most effective method is to distribute questionnaires to audiences at the last two or three concerts, productions or programs in a given season as the B & J did. This method is subject to some error because it does not take into account those people who might have attended one or more times at the beginning of the season but not in the latter part.

Another method is to mail a questionnaire to the organization's complete list of non-subscribers after the season, asking the same kind of question. This method may be slightly less accurate, depending upon how completely the mailing list reflects total single-ticket attendance. It may also produce some respondent bias toward people who are more interested in the organization and more likely to attend with higher frequency.

Despite the possibility of some margin of error in the results of each of these methods for determining Frequency, it is still important and valuable to try to calculate Reach on a continuing basis. Even if it is simply a close approximation of the real figure, it can be illuminating to have some idea of how many lives are being touched and to be able to detect trends in that very significant number.

MEASURING AUDIENCE DEVELOPMENT EFFECTIVENESS BY COST PER DOLLAR OF INCOME

Although the success of audience development programs cannot be measured by cost-effectiveness alone, a consistent method of comparing results is helpful in budgeting and evaluating sales promotion. The simplest and most direct method is to calculate how much it costs in direct expenditures (excluding staff salaries) to bring in one dollar of earned income. By using *Cost Per Dollar of Income*, an institution can measure the relative effectiveness of its various promotions as well as compare its results with those of other organizations.

In our experience, most performing arts organizations justifiably require an overall average expenditure of between 25 and 35 cents per dollar of ticket income. The Cost Per Dollar of Income is determined by dividing the total annual cost of all promotion, advertising, marketing, direct mail, public relations and publicity, audience communication and education, and sales (excluding salaries for audience development, marketing, publicity or box office staff) by the total ticket income for the season.

Obviously, the Cost Per Dollar of Income will vary substantially among the various kinds of promotions undertaken *within* an organization, depending upon the nature of the target audience. The overall average may also vary considerably from one organization to the next, depending upon the organization's characteristics.

Basically, communicating with someone who has previously participated in an organization's activities and can be identified by name is far less expensive than reaching out to an anonymous target group largely unfamiliar with the institution. Thus, developing ticket income from *within* an organization's audience family by direct mail should be possible at far less cost per dollar than selling tickets to non-attenders through paid advertising.

In most cases, income from season ticket renewals is the least expensive to develop in a performing arts organization. Such revenue can usually be produced for less than 15 cents per dollar of income, and some organizations accomplish it for as little as seven or eight cents. Selling a season ticket to someone who has previously attended the organization's offerings will cost more, and attracting a person who has never attended any events before will be even more expensive. In one analysis of cost per dollar of season ticket income done for a regional professional theater several years ago, the results showed the following:

- Subscription renewal: $.06 per $1.00

- Subscription sales to
 previous attenders: $.27 per $1.00

- Subscription sales to
 people who had never
 attended previously: $4.12 per $1.00

The most expensive income to produce is from single-ticket sales to new customers. In the SELL system, it may be necessary to budget as much as 50 or 60 cents per dollar of income in Point-of-Entry promotions. But if the names are captured and the system is designed with logical stepping stones to nurture increased involvement, then the cost per dollar of income should steadily decrease as participation and commitment increase. Eventually, a fully-committed audience member's participation may be maintained for only a few cents per dollar of income each year.

Under such circumstances, an analysis of a performing arts organization's budgeted expenditures might show the following breakdown:

- Point-of-Entry costs: $.50-.60 per $1.00

- Single-ticket sales to
 members of the family: $.35-.50 per $1.00

- New subscriptions to
 members of the family: $.15 or less per $1.00

The average, overall expenditures under these circumstances might then fall in the general range of 25 to 35 cents per dollar of income. An organization that is nearly always sold out to subscribers might have an average considerably below that range, while an institution that offers a wide variety of attactions which do not necessarily lend themselves to season ticket packaging may average more.

150

TUCSON SYMPHONY ORCHESTRA BEGINS TO SEE RESULTS FROM SELL

In 1983, the Tucson (Arizona) Symphony Orchestra (TSO) created a long-range audience development plan based on the Strategy to Encourage Lifelong Learning. It began by conducting extensive research—including audience surveys and focus group discussions—with subscribers, single-ticket buyers and people who had never attended the TSO. The study was executed by a collaborative partnership that included the music director, the managing director, the marketing and public relations director, a special committee of the board of directors and a consultant.

The most significant findings included the following:

• People who had never attended a TSO concert, or concerts of other symphony orchestras, repeatedly expressed a need to know more about symphony music in order to enjoy the concerts.

• People who *did* attend the concerts, especially single-ticket buyers, consistently stated that they enjoyed and appreciated the comments the conductor often made before a piece of music was performed. Many people requested that he discuss the music more frequently, especially before the more "difficult" contemporary works.

• The median age of the total audience was 57. The median age of subscribers to both series was 63.

The study also included a close examination of the orchestra's audience development strategy and the attendance trends of the previous three to four years.

The orchestra's attendance had been stagnant for at least four years and was now beginning to show signs of decline. The Tucson Symphony had been packaging a series of three pops concerts and a series of eight classical concerts. It also encouraged people to purchase a combination of the pops and classics. In addition, the orchestra presented a special concert featuring its chamber orchestra and had begun experimenting with "family" concerts.

The pops concerts usually included programs such as "A Night with Irving Berlin" or a concert of John Philip Sousa's music. The classical series not only included the major symphonic repertoire but also numerous contemporary pieces. The music director/conductor, William McGlaughlin, often made comments and conducted demonstrations prior to performing many of the 20th century works.

The audience development strategy had been based upon the principles of Dynamic Subscription Promotion. Nearly 65 percent of the marketing budget was designated for subscription concert sales. The remainder was dedicated to single-ticket promotion and other miscellaneous expenses. Single-ticket promotion included some advertising in the Sunday

151

newspaper. However, the orchestra concentrated most of its energy on promoting media coverage to sell single tickets.

In looking at the relationship between the concert programming and its audience development strategy, the orchestra began to realize that it was unrealistic to expect pops attenders to make the jump from attending concerts of Sousa, Irving Berlin or Broadway music to the music of Bruckner, Mahler and Elliot Carter. In its audience development strategy, the pops concerts had no relationship to the classical concerts, the primary purpose of the orchestra.

The study group began to realize that it might be possible to provide a stronger link between the two series so that it would make more sense for the audience. It might be possible to encourage pops attenders to become classical attenders if another step or two was added to the process of becoming a committed audience member.

The first family concert of light classical works had been well received by the single-ticket audience as had the holiday concert featuring the chamber orchestra. In addition, the audience that seemed most intimidated by the classical music and the contemporary works wanted more help in understanding the music. A new series was created—a stepping stone—of light classical works that included introductory comments and demonstrations by the music director. The series, named the Joy of Music, included two concerts of light classical music, "Afternoon Adventures," that appeal not only to children but also to adults, a concert by the chamber orchestra of light and familiar classics, a pops concert and the most accessible classical concert. The series helped to bridge the gap between the pops and the classical.

The orchestra also developed learning programs to help people make the transition from one series to the next. Library programs created for families involve participatory activities and relate to each of the Joy of Music concerts. Pre-concert discussions are offered prior to the Classic concerts. The *Overtures* publication is mailed to single-ticket buyers as well as to subscribers, and other learning programs are provided throughout the season such as the "Tucson Sunday Morning" show. (Both activities are described in Chapter 12.)

In order to execute the new strategy, the TSO increased its marketing and public relations budget by nearly 50 percent. Approximately 54 percent of that budget was dedicated to single-ticket promotion.

Although it is still too early to know how well the plan has worked to help people explore new kinds of musical experiences and to increase their participation and commitment, the overall TSO attendance increased by 11 percent in the first year and subscription sales increased by 26 percent in

152

the second year. In the two years since the plan was initiated, the total audience reach has increased by 44 percent (see Tables 3 and 4). In the first year, some pops attenders changed their subscriptions to the Joy of Music, while some classical subscribers who might have discontinued their season tickets became subscribers to the Joy of Music. The Median age for pops concert attenders showed signs of becoming younger, and the median age of the adult audience for the new Joy of Music series was approximately 38 years old.

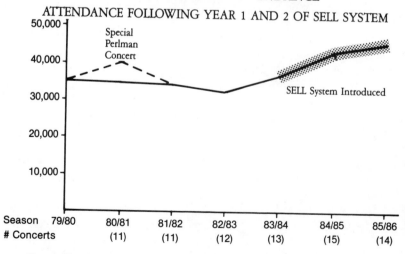

TABLE 4
TUCSON SYMPHONY ORCHESTRA: TRENDS IN TOTAL ATTENDANCE

ATTENDANCE FOLLOWING YEAR 1 AND 2 OF SELL SYSTEM

(Source: "Opening Doors to Musical Adventures: A New Approach to Audience Development for the Tucson Symphony Orchestra," by Julie Gordon, Tucson, Arizona, May 1985.)

153

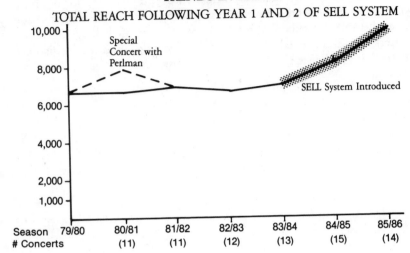

TABLE 5

TUCSON SYMPHONY ORCHESTRA:
TRENDS IN REACH

TOTAL REACH FOLLOWING YEAR 1 AND 2 OF SELL SYSTEM

(Source: "Opening Doors to Musical Adventures: A New Approach to Audience
Development for the Tucson Symphony Orchestra," by Julie Gordon, Tucson, AZ, May 1985.)

GOODMAN THEATRE FINDS AUDIENCE DEVELOPMENT SYSTEM BY ACCIDENT _____

The Tucson Symphony Orchestra is the only organization of which we are aware to have actually created an audience development strategy based on the philosophy of SELL. However, some arts groups, such as the Goodman Theatre in Chicago, have fallen into similar strategies by accident.

During the late seventies and into the early eighties, a unique system for developing new audiences began to emerge at the Goodman. It started to evolve with its first production of *A Christmas Carol*. The theater quickly discovered that the audience attracted to the holiday play was quite different in character from that which attended the regular season of plays, and it began to work with the production of the Dickens' story as a Point-of-Entry for its main series.

About the same time, the Goodman began to assist the Hubbard Street Dance Company, an energetic jazz and tap troupe based in Chicago, with management and administrative matters. Eventually, the theater decided to present the dance company in a concert at its facility. Again the audience for Hubbard Street proved to be quite different in profile from its own regular audience (primarily a much younger group), and the Goodman began to consider the possibility of converting the dance audience into theater-goers. In the following year, the Goodman presented two performances by the Hubbard Street Dance Company, and in the third year, Merrill Lynch provided financial support to present several companies in a full dance series at the Goodman venue. And the theater began to use these dance performances as Points-of-Entry to try to bring a younger group of people into its theater series.

In the meantime, the Goodman hired Gregory Mosher as artistic director. In previous years, the theater's artistic policy had been to present a conservative season of plays in a traditional, classic mode. Mosher's vision, however, was quite different. He chose to present primarily contemporary work and new plays, essentially abandoning the traditional and classical repertoire. As a result, a great many long-time subscribers abandoned the Goodman, precipitating something of a box office crisis.

As a result, the theater developed a new house with fewer seats, called it the New Theatre and devoted it entirely to Mosher's new and contemporary repertoire. The main stage was returned to classical, traditional plays. What has begun to evolve is an audience development system in which new people are introduced to the Goodman through *A Christmas Carol* and the dance series, and then are encouraged to try productions in the mainstage series and, eventually, to become subscribers in a kind of First-Stage

155

Commitment. From there, some are expected to be intrigued into sampling the New Theatre repertoire and eventually becoming committed there, too.

Although Mosher is no longer with the Goodman, the three primary stepping stones remain in place, forming the basic framework of an effective system for which the opportunity exists to develop a variety of *learning* experiences that could be a catalyst to the process.

NOTES

CHAPTER ONE

1 Rockefeller Panel Report, *The Performing Arts: Problems and Prospects*, (New York: McGraw-Hill Book Company, 1965) pp. 11-12.
2 Ibid., p. 2.

CHAPTER TWO

1 Rockefeller Panel Report, *The Performing Arts: Problems and Prospects*, (New York: McGraw-Hill Book Company, 1965) pp.4-5.
2 Baumol, William J., and Bowen, William G., *Performing Arts: The Economic Dilemma*, (New York: Twentieth Century Fund, 1966) p. 164.
3 Rockefeller Panel Report, *The Performing Arts*, p. 82.

CHAPTER THREE

1 Rockefeller Panel Report, *The Performing Arts: Problems and Prospects*, (New York: McGraw-Hill Book Company, 1965) p. 95.
2 Ibid., p. 62.

CHAPTER FOUR

1 Newman, Danny, *Subscribe Now!*, (New York: Theatre Communications Group, 1977) p. 13.

CHAPTER SIX

1 Baumol, William J., and Bowen, William G., *Performing Arts: The Economic Dilemma*, (New York: Twentieth Century Fund, 1966) p. 96.

CHAPTER NINE

1 Newman, Danny, *Subscribe Now!*, (New York: Theatre Communications Group, 1977) p. 53.

CHAPTER ELEVEN

1 Bernstein, Leonard, *The Joy of Music*, (New York: Simon & Schuster, 1959) p. 13.
2 Ibid., p. 14.
3 Ibid., p. 16.
4 Ibid., p. 16.

CHAPTER TWELVE

1 Commission on Museums for a New Century, *Museums for a New Century*, (Washington, D.C.: American Association of Museums, 1984) p. 19.
2 Ibid., pp. 31-32.
3 Ibid., p. 55.
4 Ibid., p. 55.

BIBLIOGRAPHY

CHAPTER ONE

Rockefeller Panel Report. *The Performing Arts: Problems and Prospects*. New York: McGraw-Hill Book Company, 1965.

Central Opera Service. *Central Opera Service Service Annual Surveys*. New York: Central Opera Service.

Mid-America Arts Alliance. *Tenth Annual Report*. Kansas City, Missouri.

United States Bureau of Census. *Statistical Abstract of the United States: 1966*. 87th ed. Washington, D.C., 1966.

United States Bureau of Census. *Statistical Abstract of the United States: 1985*. 105th ed. Washington, D.C., 1985.

CHAPTER TWO

Baumol, William J., and Bowen, William G. *Performing Arts: The Economic Dilemma*. New York: Twentieth Century Fund, 1966.

Horowitz, Harold. "The Federal and State Partnership in the Support of Culture in the U.S.A." Table 5: Comparison of Trend in State and Local Government Support for Recreation and Culture, 1968-1981; and for Federal and State Arts Agencies, 1966-1984 sources Levin, David J., National Endowment for the Arts, various reports, and National Assembly of State Arts Agencies, periodic reports. Prepared for Conference on Government Support to Culture in the U.S.A. and Italy, 3-4 July 1984 in Rome, Italy.

Rockefeller Panel Report. *The Performing Arts*.

Toffler, Alvin. *The Culture Consumers: A controversial study of culture and affluence in America*. New York: St. Martin's Press, 1964.

CHAPTER THREE

Beldo, Les. "A Report of Three Surveys: *A Statewide Survey*, conducted by The Minnesota Poll, Minneapolis Star and Tribune; *An In-Concert Survey* and *A Personal Interview Survey*, both conducted by Mid-Continent Surveys, Minneapolis." Conducted for the Minnesota Symphony Orchestra Association. Minneapolis, March 12, 1956.

Ford Foundation. *The Ford Foundation Annual Report: October 1, 1961 to September 30, 1962.* New York, 1962.

Foster, Donald I., and Rosmarin, Kip. "Evaluation Study (of the Ford Foundation's Program for Administrative Interns)." New York: The Ford Foundation, 1974.

Mayer, Martin. "Ford Moves in on the Arts." *Horizon*, Jan., 1962.

McCarthy, E. Joseph. *Basic Marketing: A Managerial Approach.* Homewood, Illinois: Richard D. Irwin, 1978.

Mitchell, Arnold. *The Professional Performing Arts: Attendance Patterns, Preferences and Motives.* Madison, Wisconsin: Association of College, University and Community Arts Administrators, 1984.

Rockefeller Panel Report. *The Performing Arts.*

CHAPTER FOUR

French, Ward. "The Story of the Organized Audience Movement." Prepared for Columbia Artists Management. New York, 1945.

Mayer, Martin. "Carny barker for the arts." *Forbes*, October 8, 1984.

Newman, Danny. *Subscribe Now!.* New York: Theatre Communications Group, 1977.

CHAPTER SIX

Arts Development Associates. "A Decade Later: A Report and Analysis of The Guthrie Theater Audience of 1973." Unpublished report. Minneapolis, 1973.

Arts Development Associates. "Continuing the Pursuit of Excellence." Report for William Jewell College, April 1985.

Batten, Barton, Durstine and Osborn Advertising. "Analysis of Those Attending The Guthrie Theatre During 1963." Unpublished report. Minneapolis, 1963.

Baumol, William J., and Bowen, William G. *Performing Arts.*

Cwi, David. "Changes in the U.S. Audience for the Arts." Report for The Cultural Policy Institute, 1980.

Davis, Peter A., and Griggins, Sharon L. "Arizona Theatre Company Facility Needs Assessment." Report for Arizona Theatre Company. Tucson, February 18, 1985.

DiMaggio, Paul, Useem, Michael, and Brown, Paula. "The American Arts Audience: Its Study and Its Character." Report for Center for the Study of Public Policy. Cambridge, Mass., September 17, 1977.

Gordon, Julie. "Opening Doors to Musical Adventures: A New Approach to Audience Development for the Tucson Symphony Orchestra." Report for the Tucson Symphony Orchestra. Tucson, May 1985.

Morison, Bradley G., and Fliehr, Kay. *In Search of an Audience: How an Audience Was Found for the Tyrone Guthrie Theatre.* New York: Pitman Publishing Corp., 1968.

National Research Center of the Arts. "Americans and the Arts." Conducted for Philip Morris, Inc. New York, 1984.

WAITING IN THE WINGS

Robinson, John P., Hanford, Terry, and Triplett, Timothy A. "Public Participation in the Arts, 1982: Overall Project Report." Conducted by University of Maryland, Survey Research Center for the National Endowment for the Arts. College Park, Md., 1982.

CHAPTER NINE

Newman, Danny. *Subscribe Now!*.

CHAPTER TEN

Arts Development Associates and Weinberg, Charles B., and Ryans, Adrian B. "A Study of Audiences for the American Conservatory Threatre: 1975-1977." Unpublished report. Palo Alto, Calif., 1978.

CHAPTER ELEVEN

Beldo, Les. "A Report of Three Surveys . . ."
Bernstein, Leonard. *The Joy of Music*. New York: Simon & Schuster, 1959.
Goodlad, John I. *A Place Called School: Prospects for the Future*. New York: McGraw-Hill Book Co., 1984.
Greenfield, Meg. "Creating a 'Learning Society.' " *Newsweek*, May 16, 1983.
Markgraf and Wells—Marketing and Advertising. "Audience Research Report and Analysis." Report for The Guthrie Theater. Minneapolis, June 1981.

CHAPTER TWELVE

Commission on Museums for a New Century. *Museums for a New Century*. Washington, D.C.: American Association of Museums, 1984.
Schubart, Mark. *Performing Arts Institutions and Young People—Lincoln Center's Study: "The Hunting of the Squiggle."* New York: Praeger Publishers, 1972.

CHAPTER FOURTEEN

Rockefeller Panel Report. *The Performing Arts*.

ABOUT THE AMERICAN COUNCIL FOR THE ARTS

The American Council for the Arts (ACA) is one of the nation's primary sources of legislative news affecting all the arts and serves as a leading advisor to arts administrators, educators, elected officials, arts patrons and the general public. To accomplish its goal of strong advocacy of the arts, ACA promotes public debate in various national, state and local forums; communicates as a publisher of books, journals, *Vantage Point* magazine and *ACA Update*; provides information services through its extensive arts education, policy and management library; and has as its key policy issues arts education, the needs of individual artists, private-sector initiatives, and international cultural relations.

BOARD OF DIRECTORS

Chairman of the Board
Donald G. Conrad

President
Milton Rhodes

Vice Chairmen
Eugene C. Dorsey
Susan R. Kelly
Reynold Levy

Secretary
John Kilpatrick

Treasurer
Ronald E. Compton

Past Chairmen
Marshall S. Cogan
Louis Harris
David Rockefeller, Jr.
Nancy Hanks
George M. Irwin
Judith F. Baca
Theodore Bikel

Mrs. Jack S. Blanton, Sr.
John Brademas
Marshall S. Cogan
Colleen Dewhurst
Barbaralee
 Diamonstein-Spielvogel
Peter Duchin
John Duffy
Robert Fitzpatrick
Mrs. Robert Fowler
Jack Golodner
Toni K. Goodale
Donald R. Greene
Eldridge C. Hanes
David H. Harris
Louis Harris
Linda Hoeschler
Richard Hunt
Fred Lazarus IV
Robert Leys
Lewis Manilow
James M. McClymond
Velma V. Morrison
Sondra G. Myers
Janet Oetinger

Mrs. Charles D. Peebler
Murray Charles Pfister
Mrs. Richard S. Reynolds III
W. Ann Reynolds
David Rockefeller, Jr.
Henry C. Rogers
Rodney Rood
Frank Saunders
June Stefanisin Schorr
Mrs. Alfred R. Shands III
David E. Skinner
John Straus
Roselyne C. Swig
Allen M. Turner
Esther Wachtell
Mrs. Gerald H. Westby
Mrs. Pete Wilson

Legal Counsel
Howard S. Kelberg

Special Counsel
Jack G. Duncan

162

MAJOR CONTRIBUTORS

At press time, special thanks are extended to the following for their contributions in support of ACA's operations, programs, and special projects.

BENEFACTORS ($25,000 and up)

Aetna Life and Casualty Foundation • American Telephone & Telegraph Company
Eleanor Naylor Dana Trust • Exxon Corporation • Gannett Foundation
The National Endowment for the Arts • The Reed Foundation

SUSTAINERS ($15,000-$24,999)

Robert H. Ahmanson • Bay Foundation • The Coca Cola Company
Metropolitan Life Foundation • Rockefeller Foundation • The Ruth Lilly Foundation
The San Francisco Foundation

PATRONS ($10,000-$14,999)

ARCO • Betsy M. Babcock • Equitable Life Assurance Society • Knoll International
New York State Council on the Arts • N.W. Ayer Inc.
Philip Morris Companies, Inc. • Rev. and Mrs. Alfred Shands III

DONORS ($5,000 to $9,999)

The Allstate Foundation • Ashland Oil, Inc. • Ameritech • BATUS, Inc.
Bell Atlantic • Mrs. Jack S. Blanton, Sr. • Bozell, Jacobs, Kenyon and Eckhardt
CBS Inc. • Dayton Hudson Foundation • Ford Motor Fund • Louis Harris & Associates
IBM Corporation • Susan R. Kelly • Lewis Manilow • Mobil Foundation, Inc.
Morrison-Knudsen Company, Inc. • New York Times Company Foundation
Mrs. Charles Peebler • Murray Charles Pfister • The Prudential Foundation
RJR Nabisco, Inc. • Scurlock Oil Company • Shell Companies Foundation
Southwestern Bell • John Straus • Mr. and Mrs. Richard L. Swig
Warner-Lambert Company • Whirlpool Foundation • Xerox Corporation

CONTRIBUTORS ($2,000-$4,999)

Alcoa Foundation • Allied-Signal, Inc. • Edward M. Block • Borg-Warner
Corporation • Bristol-Myers Fund • The Chevron Fund • Donald G. Conrad
Barbaralee Diamonstein-Spielvogel • Eastman Kodak Company • Ethyl Corporation
Toni K. Goodale • Eldridge C. Hanes • Mr. & Mrs. John G. Hoeschler
Knight Foundation • Monsanto Fund • New York Life Foundation
The Pfizer Foundation • Phillips Petroleum Foundation • Procter & Gamble Fund
Raytheon • RCA • Mr. & Mrs. Richard S. Reynolds, III • David Rockefeller, Jr.
Rubbermaid Incorporated • Daniel I. Sargent • June Stefanisin Schorr
Sears, Roebuck & Company • C.W. Shaver & Company • David E. Skinner
Allen M. Turner • Union Pacific Foundation • United Airlines
Mrs. Gerald H. Westby • Mrs. Thomas L. Williams • Westinghouse Electric Fund

FRIENDS ($1,000 to $1,999)
Morris J. Alhadeff • American Broadcasting Companies, Inc.
American Express Foundation • B.T. Foundation • Anne Bartley • Bell South
Binney & Smith • Houston Blount • William A. Brady • Mrs. Martin Brown
Alan Cameros • Ed Lee and Jean Campe Foundation • Mrs. George P. Caulkins, Jr.
Mrs. Jay Cherniak • Chrysler Corporation • CIGNA Foundation
Thomas B. Coleman • Cooper Industries Foundation • Mrs. Howard Cowan
Dart & Kraft, Inc. • Mrs. George Dunklin • Sunny Dupree
Mr. & Mrs. Robert Fowler • Lee Gillespie • Greyhound Corporation
Mrs. John Hall • R. Philip Hanes, Jr. • Joan W. Harris
H.J. Heinz Company Foundation • Alexander Julian • Lynn Julian • Henry Kates
Mrs. Albert S. Kerry • John Kilpatrick • Henry Kohn • Mrs. C.L. Landen, Jr.
Robert Leys • Thomas B. Lemann • Roxana Lorton • Pamela Miles
Mrs. Velma V. Morrison • H. Keith Nix • Diane Parker • Henry C. Rogers
Frank A. Saunders • Security Pacific Foundation • Dr. James H. Semans
Textron Charitable Trust • Times-Mirror Company • Mrs. John E. Veldy, Jr.
Esther Wachtell • Lawrence A. Wein • Mrs. William F. Whitfield
Elaine Percy Wilson • Mrs. R. Dan Winn